FREE THE TIPPLE

Other cocktail books by Jennifer Croll

Dressed to Swill
Runway-Ready Cocktails Inspired by Fashion Icons
Illustrated by Daiana Ruiz

Buzzworthy
Cocktails Inspired by Female Literary Greats
Illustrated by Rachelle Baker

FREE THE TIPPLE

TIPPLE

KICKASS COCKTAILS
INSPIRED BY ICONIC WOMEN

Jennifer Croll
Illustrations by Kelly Shami

Prestel
Munich · London · New York

Contents

Introduction

The Mary Pickford

2 shots light rum
2 shots pineapple juice
1 tsp grenadine
1 dash maraschino liqueur
Garnish: 1 maraschino cherry

Shake all ingredients with ice
and strain into a cocktail glass.
Garnish with a maraschino cherry.

Trying to capture someone's personality in a cocktail is a time-honored tradition. Take the Mary Pickford. Pickford was a silent movie star who, at the turn of the century, was the most renowned actor in the world—only Charlie Chaplin could match her fame. She starred in 52 feature films and was nicknamed "the girl with the curl" and "America's Sweetheart." Her popularity overlapped with the era of Prohibition in the US, when many prominent bartenders fled for countries where they could still practice their craft. While Pickford was filming a movie in Cuba in the early 1920s, an émigré American mixologist created a drink in her honor. A mixture of rum, pineapple juice, grenadine, and maraschino liqueur, it's sweet and charming in the way Pickford was perceived to be, but its rum-forward character is also a reflection of the country where it was created and the tastes of the time.

Sometimes, a tribute cocktail can become more famous than the person for whom it was named. The most obvious example is the Margarita, which, legend goes, was concocted in Ensenada, Mexico, in the early 1940s, when Margarita Henkel, the daughter of a German ambassador, helped a bartender taste-test his new creation. Today, Margarita Henkel isn't a household name, but her eponymous cocktail sure is.

Whoever they're named after, tribute cocktails are a celebration—a little toast to someone we admire. And this is exactly what *Free the Tipple* aims to do. It gives kudos to 60 iconic women whose contributions to culture have shaped our world. The inspiration for each cocktail varies: some draw from a particular woman's work, some from her background, and some from her style, while others are a direct reflection of her favorite drink. Some are more ephemeral and borrow from her personality—a strong woman, for example, may have inspired a strong cocktail.

Nigella Lawson likes to say that she's not a chef, she's an eater. I'll follow her lead: I'm not a bartender, but I appreciate a good cocktail. I designed the cocktails in this book to be easy to make; they're all drinks I make myself, at home. They're also meant to be fun. With a few simple ingredients, you can raise a glass to brilliant, creative, ground-breaking women, many of whom are already your heroes, and some of whom you may be meeting for the very first time.

Jennifer Croll

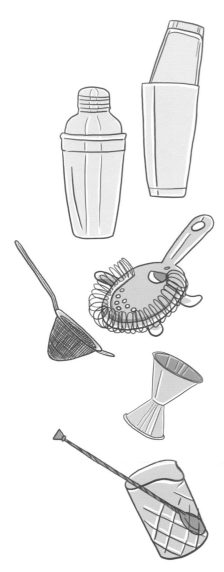

Basic Equipment

You'll need a few tools in order to properly assemble a cocktail:

Shaker
There are different varieties of shaker. The standard shaker is metallic, with three parts: a bottom, a built-in strainer, and a cap. Standard shakers are aesthetically pleasing and easy to use. Another option is a Boston shaker, which has two roughly equal-sized parts: a metal bottom and a glass top. If you use one of these you'll also need to buy a strainer, since they don't have one built in. Boston shakers are popular with professional bartenders because they're unfussy and easy to clean.

Strainer
You'll need one of these if you use a Boston shaker. There are different types: a Hawthorne strainer is a steel paddle that fits over the end of your Boston shaker and does the trick for most drinks, while a fine strainer is used for drinks like Martinis, where you don't want little pieces of ice or citrus to ruin the smooth surface of the drink.

Jigger/shot glass
A jigger or shot glass is used for measuring alcohol or other liquids for cocktails. They come in different sizes, ranging from 1 to 2 oz / 30 to 60 ml.

Mixing glass
Not all cocktails are shaken. For those that are stirred, you'll need a mixing glass. You can buy one specifically made for the job, but you can also just use a pint glass.

Bar spoon
With its long, skinny handle, a bar spoon is used for mixing drinks and measuring small quantities of spirits.

Muddler

A muddler is a tool used to mash fruits or herbs at the bottom of a drink. They can be made from wood or metal, though the metal varieties tend to have more longevity.

Citrus squeezer

You don't need a fancy juicer to squeeze citrus fruits. There are different types, but the easiest is the hand-held press, which allows you to squeeze a lemon or lime one half at a time.

Blender

If you want to make blended drinks, you'll need a blender. It doesn't need to be expensive or high-end, but you do need one that can crush ice.

Key

In this book,
1 shot = 1 oz / 30 ml

Glassware

Half the fun of cocktails is in the presentation, and glassware is a big part of that. Many cocktails are traditionally served in a certain type of glass—a good example is the Martini glass, made to suit its namesake drink. You don't have to be dogmatic about glassware, though; there's always room for experimentation, and sometimes you'll see cocktails being served in vessels that weren't originally meant for cocktails at all, like Mason jars or teacups.

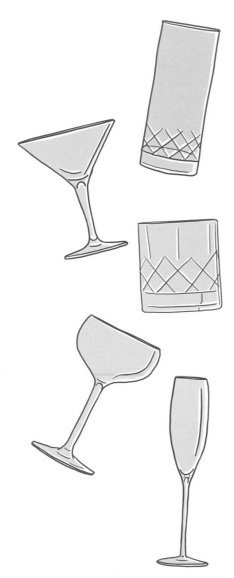

Traditional glasses

Highball / Collins glass
Highball and Collins glasses are very similar and are often used interchangeably. Both are tall, narrow glasses meant for serving mixed drinks (though the Collins glass is somewhat narrower and taller).

Martini / cocktail glass
Like highball and Collins glasses, Martini and cocktail glasses aren't much different from one another, and you likely already think of them both as Martini glasses. They're conical in shape and meant for cocktails served straight up without ice.

Old Fashioned / rocks glass
Old Fashioned glasses (sometimes called lowball glasses) are short and typically used for drinks served on ice—hence why they're also called rocks glasses.

Coupe
Coupe glasses were originally designed to serve champagne, but the wide mouth isn't that great for bubbles. Today, they're a popular choice for mixed drinks served straight up.

Champagne flute
Flutes are tall, slender glasses with small mouths designed to retain the bubbles in sparkling drinks. They're great for any cocktail made with sparkling wine.

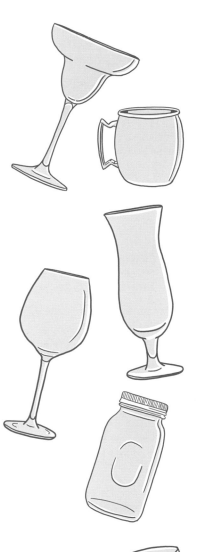

Margarita glass
You can serve a Margarita in different types of glass (on the rocks, they're often served in a rocks glass, or for fancier settings, a cocktail glass), but its namesake glass is a more curvaceous version of a cocktail glass.

Moscow Mule mug
A Moscow Mule is traditionally served in a copper mug with a handle. Make sure you get one that's lined with another metal, like stainless steel, as acidic drinks (such as mules!) erode the copper.

Hurricane glass
Hurricane glasses have a distinct tulip shape and are used to serve tropical or Tiki drinks. Their little cousin is the Poco Grande, a slightly smaller glass often used for Piña Coladas.

Wine glass
Sure, wine glasses are for wine, but they're used for wine cocktails, too, including Sangria.

Nontraditional glasses

Mason jar
Mason jars are used for canning and preserving food but, lately, they've become a hip vessel for serving cocktails. Bonus: if you pop a lid on, you can take your drink with you for a picnic.

Teacup
During the 1920s Prohibition era in the US, alcohol was sometimes sneakily served in teacups. Now, it's a trendy serving choice that's less about subterfuge and more about making your cocktail Instagram-worthy.

Types of Alcohol

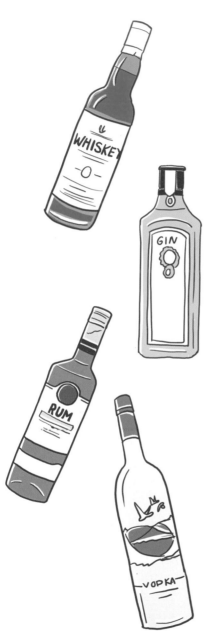

A cocktail's character is often dictated by the type of alcohol it contains. Here are a few of the most common varieties you'll encounter in this book:

Whiskey

Nobody can agree on how to spell whiskey (or, whisky), but its rich flavor has made it one of the most popular kinds of liquor used in cocktails. Whiskey is distilled from different types of grain—barley, corn, rye, or wheat—and then aged in oak barrels. The most common are Scotch (malted grain whiskies made in Scotland and aged for a minimum of three years), bourbon (American whiskeys made from corn), and rye (made from rye, and often produced in Canada or the US). Famous whiskey cocktails include the Old Fashioned, Manhattan, and Whiskey Sour.

Gin

Gin is a clear alcohol defined by the flavor of juniper berries. Some gins add juniper post-distillation, while others (distilled gins and London dry gins) involve it in the distillation process. While gin has to taste predominantly of juniper in order to be considered gin, it often features other botanical flavors too, including citrus, anise, coriander, cucumber, and rose petals. It's a favorite with bartenders, and you can find it in drinks like the Negroni, Martini, and French 75.

Rum

Rum is distilled from sugarcane or molasses and has a rich, sugary flavor. There are many different varieties, from light rum (which is basically clear) to dark rum (which is full-bodied and often consumed straight up). It's predominantly produced in the Caribbean and Latin America, and is often used in cocktails with a tropical flavor: Mai Tais, Mojitos, and Daiquiris. A close cousin to rum is cachaça, which is produced in Brazil from fermented sugarcane juice and used in Caipirinhas.

Vodka

Vodka is the most neutral spirit, clear and almost flavorless. It's made from fermented potatoes and grains, and is the dominant spirit of Russia and Scandinavia. Famous vodka cocktails include the Moscow Mule, White Russian, and Vodka Martini.

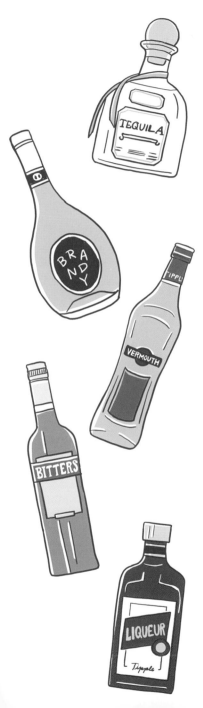

Tequila and mezcal

Tequila is distilled from the blue agave plant, and its production is centered around the Mexican town that inspired its name, Tequila. There are different types, ranging from silver (which is clear and unaged) to añejo (aged a minimum of one year, with a rich amber color). Tequila is technically a type of mezcal, a similar beverage also made with agave (though not blue agave). Unlike tequila, mezcal has a distinctive, smoky flavor. You can find tequila and mezcal in cocktails like the Margarita and Paloma.

Brandy

Brandy is a distilled wine, often aged in casks and consumed as a dessert drink. The most famous brandy is cognac, which is produced in pot stills in a specific region of France, around the town of Cognac. It was a popular cocktail ingredient in the first half of the 20th century and you can find it in many classic drinks, like the Sidecar, Vieux Carré, and Brandy Alexander.

Vermouth

Vermouth is a fortified wine flavored with botanicals. It comes in both dry and sweet varieties, and punches above its weight as an essential ingredient in many classic cocktails: you'll find it in the Martini, Manhattan, Negroni, Boulevardier, and Americano.

Amari

Digestif and aperitif bitters, or amari (the plural of *amaro*, which is Italian for "bitter"), are spirits flavored with bitter roots and herbs, traditionally used to stimulate the appetite or digestion or used as a hangover cure. The most cocktail-friendly digestif bitters are Campari and Aperol, but other famous versions include Jägermeister and Fernet Branca. Cocktails that rely on bitters include the Negroni (which uses Campari) and the Aperol Spritz.

Liqueurs

Liqueurs are sweet, flavored alcoholic beverages, and there's an almost endless variety of them to suit your every cocktail whim. Two common examples are triple sec, which has a bright, orange flavor, and crème de cassis, a sweet, jammy liqueur made from blackcurrants.

Other Ingredients

Cocktails rely on the artful layering of different flavors. Those details can come from a variety of ingredients, not just booze:

Citrus juices
Most cocktail recipes involve either lemon, lime, or grapefruit juice. Always use fresh juice—it tastes better, and all you need is a cheap hand-held squeezer.

Simple syrup
Simple syrup is a sugar and water mixture used to sweeten cocktails. The most common version uses a 1:1 ratio of sugar to water. To make it, add sugar and water to a saucepan, heat on medium heat until the sugar is dissolved and the liquid is clear, then take off the heat and allow to cool. You can store it in the fridge for up to a month.

Flavored syrup
Flavored syrup is an easy way to add a twist to a basic drink. It's simple to make, too: just add whatever ingredient you'd like while the simple syrup is hot and remove it after the liquid cools. Try fruit such as blueberries or strawberries, herbs such as thyme and rosemary, spices like cinnamon and cloves, or flowers like rose and lavender.

Infused alcohols
You can add flavor to alcohols, too. All you need to do is pick your liquor (vodka is the most common alcohol used in infusions owing to its neutral flavor, but you can infuse basically anything) and choose a complementary flavor. Combine your flavoring and your alcohol in a clean, airtight container (such as a Mason jar), seal tightly, and leave somewhere cool and dark until the liquor has absorbed enough flavor. Strain out the flavoring, and store in an airtight container again. Some ingredients, like jalapeño peppers, don't need much time to infuse at all—just a few hours—while others (ginger, lemongrass) need up to a week. Most things (fruit, herbs) need about three to four days.

Bitters

Cocktail bitters are flavorings added to cocktails in drops or dashes to create more complex flavor profiles. There are different types of bitters: aromatic (strong botanical flavors; Angostura bitters are an aromatic), citrus (orange is the most common), herbal, spice, fruit, and nut.

Shrubs

Shrubs are sweet, fruit-based drinking vinegars that bring an acidic tartness to cocktails. To make a shrub, take any fruit, chop it into small pieces and roll them in sugar, and store overnight in an airtight container in the fridge. Strain the fruit out of the syrup that forms, add an equal measure of vinegar (cider vinegar is a good choice), funnel into a container, and store in the fridge.

Eggs and foamers

Some cocktail recipes call for egg whites to create a silky foam at the top of the drink. It's best to use fresh eggs for this, and you can separate the white from the yolk using a slotted spoon. But if you're vegan or don't like consuming raw eggs, you can substitute in aquafaba, a fancy-sounding word that refers to the liquid—which is typically discarded—found in a can of chickpeas. Just sub in the same measure of aquafaba as you would use of egg whites (a typical egg white is about 1 oz / 30 ml).

Garnishes and Rims

Garnishes and rims are visual flourishes that can give a cocktail a little edge or, at their most extreme, transform it into a work of art. They're an easy way to make even the most basic drink look like something special.

Citrus
The most common garnishes are citrus fruits—which makes total sense when you consider that many drinks are made with fresh lemon, lime, or grapefruit juice. You can try adding a citrus round—a thin, circular cross-section of the entire fruit cut with a knife—for a fun, tropical feel, or a citrus wedge (that familiar bar garnish) if you want to squeeze the juice into your drink. A citrus twist is the classiest of the bunch; to make one, slice off a thin strip of citrus peel using a knife or a peeler, twist it or wrap it around a straw to give it a spiral shape, then drape over the rim of a glass. It's quick, sophisticated, and adds both the aroma and flavor of citrus oil to your drink.

Fruit
Citrus isn't the only fruit garnish in town. You can use almost any kind of fruit as a garnish, including cherries, pineapple, apples, strawberries, and everything in between (including olives, which, yes, are a fruit). Cut a vertical slice in the fruit and mount it on the side of the glass, or skewer it on a cocktail pick and lay it across the top.

Edible flowers
Flowers bring a lush, feminine, botanical aesthetic to your drink. There are many different types of edible flower, including common garden flowers like cornflowers, nasturtiums, pansies, squash blossoms, and dandelions. If you don't feel like foraging through your flowerbed, specialty grocery stores often sell edible flowers in the fresh herbs section.

Herbs

Herb garnishes can range from understated (a delicate sprig of sage) to downright wild and overgrown (several bunches of mint or basil). Herbs don't just look pretty—they also add an intoxicating aroma to your cocktail, which you'll inhale each time you take a sip. Before you add your herb garnish, press on the leaves to release their essential oils (but not so hard that you crush them).

Shrimp and pickles

If you want your garnish to be able to look you in the eye, a shrimp is a good bet. Shrimp and pickled vegetables (carrots, green beans, asparagus, onions) are go-to garnishes for savory drinks like Bloody Marys and Caesars.

Umbrellas, straws, and other inedibles

Tiny umbrellas bring a playful, campy mood to a cocktail; you'll typically find them used as garnishes for tropical drinks. The same goes for wacky, colorful plastic garnishes like miniature giraffes and elephants (which, let's face it, all end up in compromising positions by the end of the night). But you might want to consider eschewing the plastic altogether, particularly when it comes to straws, which just end up in the trash. Reusable stainless steel straws are ten times classier than plastic ones, and widely available, too.

Rims

Your first experience with a cocktail rim was likely the salted edge of a Margarita glass, but there are other options, too. You can use either sugar or salt, and experiment with mixing in other herbs and spices (try a chili salt mixture, or cinnamon sugar). To rim a glass, pour the salt or sugar in a thin layer onto a plate, run a lime or lemon around the edge of your glass, and then dip the glass into the rimming mixture.

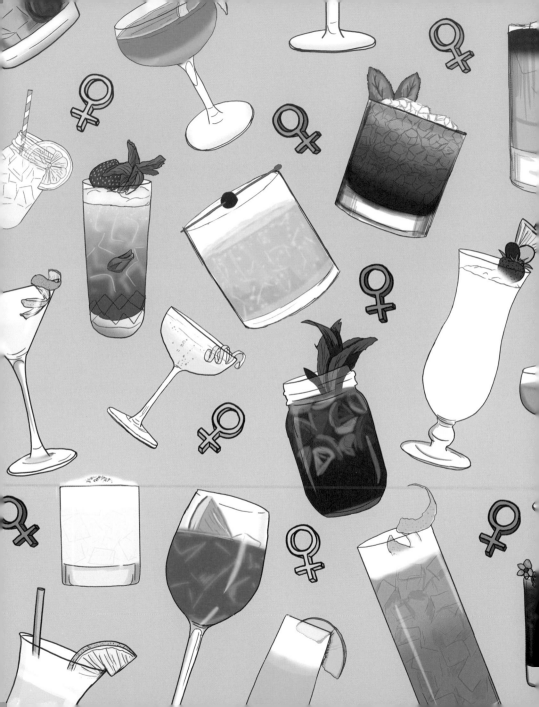

FRIDA KAHLO

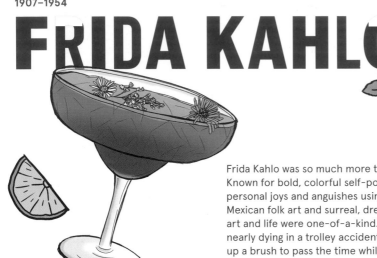

The Frida Kahlo

For the hibiscus syrup
Hibiscus tea
½ cup / 100 g sugar

Bring ½ cup / 120 ml of water to a boil. Add 2 teabags and allow to steep for 15 minutes. Remove teabags, add sugar, and bring to a simmer again, stirring until the sugar has dissolved. Allow to cool.

For the cocktail
2 shots silver tequila
1 shot fresh lime juice
1 shot hibiscus syrup
Garnish: edible flowers

Combine ingredients in a shaker full of ice. Shake vigorously. Serve over ice in a Margarita glass and garnish with lots of edible flowers (you can get these at specialty grocery stores).

Frida Kahlo was so much more than just a fierce unibrow. Known for bold, colorful self-portraits that revealed her personal joys and anguishes using a mixture of traditional Mexican folk art and surreal, dreamlike symbolism, her art and life were one-of-a-kind. She became a painter after nearly dying in a trolley accident when she was 19, picking up a brush to pass the time while she was an invalid. Kahlo painted to ease physical and mental pain, including the heartache caused by her tumultuous on-again, off-again relationship with the famous muralist Diego Rivera. He cheated on her, she cheated on him, but they were better together than apart.

Through it all, Kahlo was always the life of the party. She danced and drank until late at night and held her own in tequila drinking challenges against men who were twice her size. She also loved nature: her paintings are full of animals and plants, and her signature look was a vibrant, traditional dress paired with ribbons and flowers in her dark hair. "I paint flowers so they will not die," she once said. That's why she has inspired this cocktail, a hibiscus-flavored Margarita. In Mexico, bright pink hibiscus flowers are called Jamaica flowers, and they are considered a delicacy. So is tequila. Clearly, they belong together.

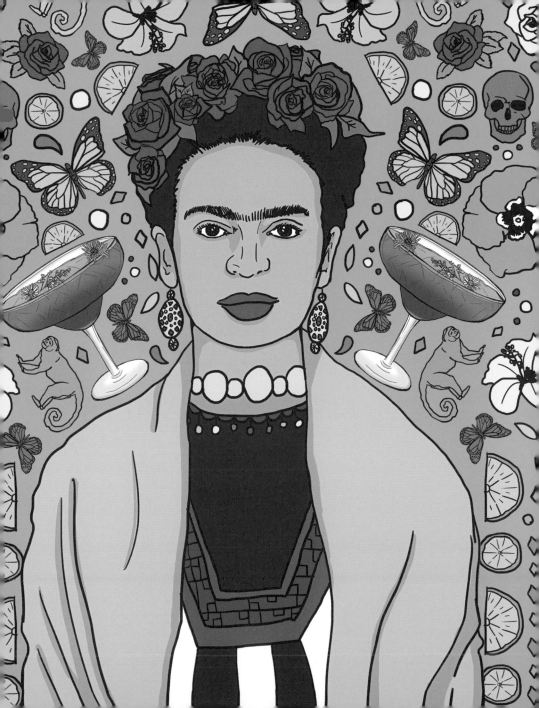

b. 1981

BEYONCÉ

The Beyoncé

For the lemonade
¼ cup / 50 g sugar
2 shots fresh lemon juice

**Add 1 cup / 240 ml water and sugar
to a small pot and bring to a simmer.
Allow to cool and add lemon juice.**

For the cocktail
1 shot bourbon
Lemonade
Garnish: lemon round

**Pour bourbon into a medium-sized
Mason jar full of ice. Top with
lemonade, garnish with a lemon
round, and add a straw.**

If America has a monarch, it's Beyoncé—they don't call her Queen Bey for nothing. The self-avowed feminist is as famous for putting Black female pride in the spotlight as she is for her music.

Her career has been long: as a child in Houston she performed in girl groups, and by the time she was a teenager she was racking up hits (and coining the term "bootylicious") in Destiny's Child. She later embarked on a solo career, married Jay-Z, and had three children: Blue Ivy, followed by twins Sir and Rumi. While Beyoncé's early songs celebrated liberated ladies (cue "Independent Women Part I"), her later material transformed her into a pop cultural den mother. Her 2016 album *Lemonade* was a very public reckoning of her relationship with Jay-Z after he had an affair; the video for "Hold Up," where she destroys cars with a baseball bat and a grin on her face, was group catharsis for every woman in the Beyhive. Her Super Bowl performance of "Formation" the same year truly made waves: all her backup dancers were dressed like Black Panthers, while the lyrics were a defiant assertion of Black pride. And with 2022's *Renaissance*, she celebrated post-pandemic hedonism and Black joy through dance music—with an ultra-sexy Lady Godiva-inspired cover to boot.

Despite her fame, Beyoncé has never forgotten where she's from. It makes sense that she'd probably like a little bit of bourbon—the most famous liquor from the Southern US—in her lemonade.

22

1934–2021

JOAN DIDION

The Joan Didion

2 shots bourbon
1 shot sweet vermouth
2 dashes Angostura bitters
1 maraschino cherry

Pour bourbon and vermouth into a rocks glass half-filled with ice. Add bitters and a cherry, and crush the cherry inside the glass with a spoon. Stir.

"We tell ourselves stories in order to live," wrote the coolly observant Joan Didion in her essay collection *The White Album*. A prolific novelist, journalist, and screenwriter, Didion' brilliantly restrained, melancholic prose and aloof glamour made her one of literature's most eminent tastemakers.

Didion grew up in Sacramento, California, and found her way into the writing world after winning an essay contest for *Vogue* during her final year at college. The prize was a job as a research assistant at the magazine and she moved to New York to take it, gradually working her way up the ladder to features editor. She married another writer, John Dunne, and, after she published her first novel, the two moved back to California. There, Didion became a part of the Hollywood social set and wrote magazine articles about cultural upheaval at the tail end of the '60s, which were collected and published in a book called *Slouching Towards Bethlehem*. Together with her husband, she also wrote a number of screenplays, including *The Panic in Needle Park* and *Play It As It Lays*, the latter of which was an adaptation of her own novel of the same name. Didion's later nonfiction books, *The Year of Magical Thinking* and *Blue Nights*, dealt frankly with the subjects of death and aging and, for the former, she won a Pulitzer Prize. She stayed in the public eye into her 80s (even appearing in an ad for the edgy fashion brand Celine in 2015), and after her death in 2021, she remains a literary and cultural icon.

While Didion's canon revolves around California, she found her path in New York, and it's easy to imagine her drinking a Manhattan, an elegant, take-no-bullshit drink that never goes out of style.

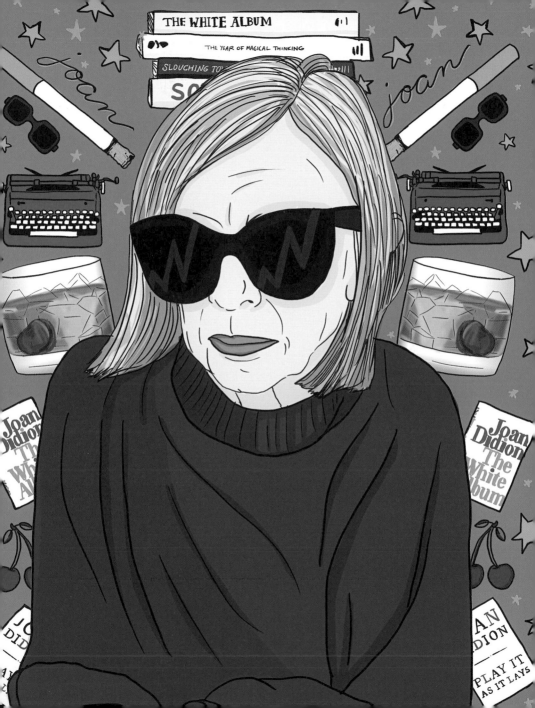

MARGARET CHO

Race, sexuality, eating disorders—nothing is off-limits in the explicit routines of comedian Margaret Cho. Nicknamed "the patron saint of outsiders," she's been breaking boundaries and provoking hecklers with her ribald jokes since the early '90s.

Cho first began performing stand-up as a teenager in San Francisco, drawing inspiration for jokes from her close relationship with her Korean immigrant parents. But there was darkness in her childhood: she was bullied at school and molested by a family friend, and later made this painful material part of her act. She said, "Sharing my experience of being beaten and hated and called ugly and fat and queer and foreign and perverse and gluttonous and lazy and filthy and dishonest...heals me, and heals others when they hear it—those who are suffering right now."

In 1994, Cho's success on the comedy circuit led to a television show being created just for her, called *American Girl*. At the time it broke ground for being one of the first major TV programs centered on an Asian American family, but the focus focus on Cho's own image caused her to develop an eating disorder and escape into substance abuse. Recovering and healing from her illnesses became the subject of her first one-woman show and an autobiography of the same name, *I'm the One That I Want*. Since then, her material has grown more political: she came out as bisexual and became a fierce campaigner for LGBTQ rights and marriage equality. More recently, she claimed her rightful place as a den mother in the movie *Fire Island*—a role that mirrors her present-day mentorship to queer and Asian performers.

Even today, Cho's genuine don't-give-a-fuck attitude makes her stand out from the crowd. Her drink is a Diablo, a cocktail that's delicious precisely because it's a little bit naughty.

The Margaret Cho

1½ shots reposado tequila
½ shot crème de cassis
½ shot fresh lime juice
Ginger beer
Garnish: lime round

Pour the tequila, cassis, and lime juice into a shaker with ice and shake. Strain into a Collins glass full of ice and top with ginger beer. Garnish with a lime round.

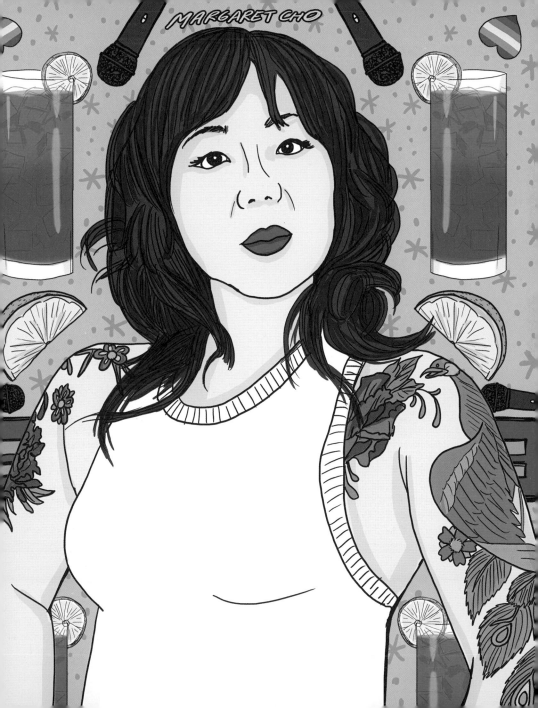

SOFIA COPPOLA

The female gaze reigns supreme in the films of award-winning director, screenwriter, and producer Sofia Coppola. As the daughter of lauded Italian American director Francis Ford Coppola (the man behind *The Godfather*), she's been film-making royalty since birth, and had an early start as a child actor in some of her dad's films. But it was *The Virgin Suicides*, her 1999 directorial debut, that cemented her role in the public consciousness as girlhood's chief auteur. Since then, she's helmed a series of female-fronted movies, from *Marie Antoinette* to *Lost in Translation*, *Somewhere*, *The Beguiled*, and *Priscilla*, that share a common sensibility and aesthetic: light, airy, and drenched with feminine ennui. Coppola gives her muses—frequently, ethereal blondes like Kirsten Dunst, Scarlett Johansson, and Elle Fanning—multifaceted roles as driven characters with complicated lives and storylines that aren't tethered to male fantasy.

The magic of Coppola's films extends to her own life. Feted as an It Girl since the early '90s, she's been a model, collaborated on a clothing line with Sonic Youth's Kim Gordon, and directed an opera. She lives with her two children and husband Thomas Mars, better known as a member of the band Phoenix, in New York, but travels regularly to Paris—a city that inspires her film-making with its beautiful colors and atmosphere.

Coppola deserves a drink as unapologetically girlish and shamelessly strong as her films. Prosecco gives a nod to her Italian heritage, elderflower liqueur lends a complicated sweetness, and gin, a lot of backbone.

The Sofia Coppola

1 shot gin
½ shot St-Germain
Prosecco
Garnish: lemon twist

Pour gin and St-Germain into a coupe glass; top with prosecco. Garnish with a lemon twist.

28

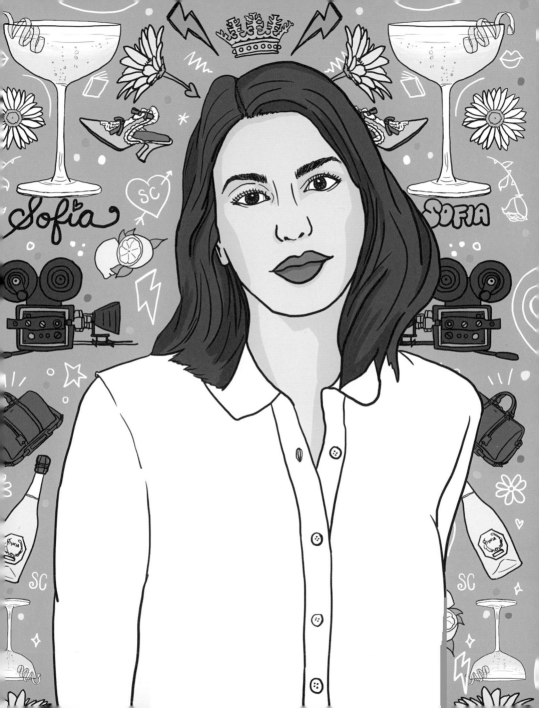

EDITH HEAD

The Edith Head

2 shots cognac
1 shot Cointreau
1 shot fresh lemon juice
Garnish: orange twist

Pour ingredients into a cocktail
shaker filled with ice. Shake
and strain into a cocktail glass.
Garnish with an orange twist.

Whenever you've watched a classic Hollywood film, you've likely seen the work of Edith Head. The prolific and beloved costume designer defined the aesthetics of silver-screen stars for more than 50 years.

Head didn't always intend to become a costume designer. In fact, her first career was as a high school teacher, and she only enrolled in night school art classes so she could show her students how to draw. When she caught wind that Paramount Pictures was looking to hire a sketch artist, she cheekily "borrowed" the work of some of her art school peers to put in her portfolio. Her lack of relevant credentials didn't hold Head back, though, and she learned on the job. By the 1930s, her chic pieces started to be worn by some of the biggest names of Hollywood's Golden Age, and she went on to dress stars like Ginger Rogers, Audrey Hepburn, and Grace Kelly.

Head was the first woman to lead the design department of a major studio, and she remained one of Tinseltown's top costume designers right up until her death at age 83, when she was working for Universal. Over her lifetime, she earned 35 Academy Award nominations and won eight; even today, she holds the record as the woman with the most Oscars.

Despite her massive influence on film fashion, Head herself maintained a quirky but distinctly unflashy style, with a short bob, round glasses, and smart skirts and jackets. Her drink is a Sidecar, a cocktail that isn't trendy or ostentatious, but has boasted some serious staying power in bars.

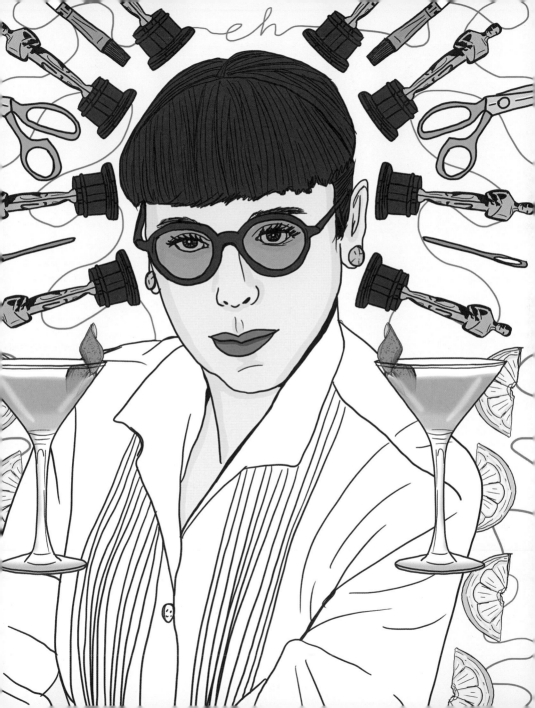

b. 1981

SERENA WILLIAMS

The greatest tennis player of all time—to many, that's Serena Williams. Her powerful serve, aggressive style, and dramatic comebacks have won her the most Grand Slams of anyone during the Open Era of the sport, male or female, in history, and many of today's young stars, from Coco Gauff to Naomi Osaka, say that Williams paved the way for their success.

Williams grew up with four sisters in Compton, California, and started playing tennis at the tender age of three. When she was nine, the whole family moved to West Palm Beach, Florida, so that she and her older sister Venus could attend a prestigious tennis academy. She made her professional debut in 1995, at age 14, while she was still in high school. Throughout her career, Williams played both with and against Venus and, in 2002, she defeated her sister to take on the number one world ranking. She stepped away from tennis in 2017 to give birth to her daughter, Olympia, with husband Alexis Ohanian, but made her comeback by 2018. In 2022, her performance at the US Open was celebrated as her retirement as she "evolved" away to grow her family—but she soon made it clear she hadn't left the court for good.

Her athleticism and dress sense have changed tennis forever. Williams' muscular power on the court overwhelmed her opponents, while her charisma made her a celebrity. Her ensemble at the 2004 US Open, a denim skirt and knee-high boots, caused a furor in the fashion world and, in the years since, her chic street style has earned her coverage in *Vogue*.

Williams' drink is an updated Pimm's Cup, the classic tipple of Wimbledon. This version includes strawberries, mint, and ginger beer.

The Serena Williams

1 strawberry
1 mint sprig
2 shots Pimm's No. 1
Ginger beer
Garnish: strawberry, mint sprig

Cut 1 strawberry lengthwise into several slices and pull the leaves off the mint sprig. Add sliced strawberry and mint leaves to a Collins glass and lightly muddle. Add Pimm's No. 1, fill the glass with ice, and top with ginger beer. Garnish with a strawberry cut so it can be balanced on the glass's rim, and a second mint sprig pushed down into the glass.

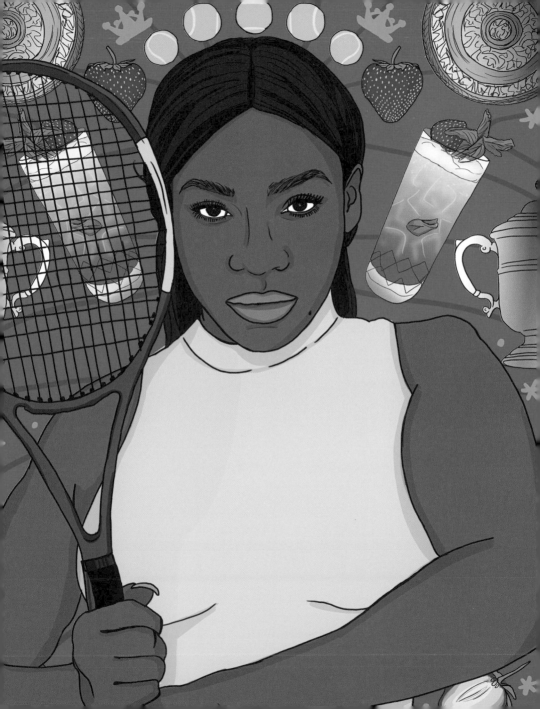

ALISON BECHDEL

The Alison Bechdel

1 shot mezcal
1 shot Campari
1 shot sweet vermouth
Garnish: orange twist

In a mixing glass, add ingredients and stir over ice. Strain over ice into a rocks glass and garnish with an orange twist.

American cartoonist Alison Bechdel's comic strip *Dykes to Watch Out For* debuted in 1983. One of the earliest pop culture representations of lesbians, it followed the lives of a cast of queer female characters for 15 years. In 1985, she published a strip of *DtWOF* called "The Rule," which set out the parameters of what would come to be known as the Bechdel Test, completely changing the way we look at film. In it, one of the characters states that she'll only go see a movie if: 1) it features at least two named women, 2) the women talk to each other, and 3) their conversation is about something other than a man. Bechdel hadn't anticipated the reach this strip would have, but today the test is the best-known barometer for female representation in cinema—and only about 50 percent of movies pass it.

Bechdel's work didn't stop with *DtWOF*. *Fun Home*, her first graphic novel memoir, pushed her from indie credibility to mainstream success. Published in 2006, it chronicles her coming out as a lesbian and her relationship with her dad, a closeted gay man. Hailed as one of the best books of the year, it helped cement the status of graphic novels as literature, landed Bechdel a coveted MacArthur "genius grant," and was later made into a Tony Award-winning Broadway musical. She followed that with two other graphic memoirs: *Are You My Mother?*, exploring her troubled relationship with her emotionally distant mom, and *The Secret to Superhuman Strength*, about her lifelong pursuit of exercise.

Bechdel has said, "The secret subversive goal of my work is to show that women, not just lesbians, are regular human beings." Her cocktail, a mezcal Negroni, combines three different types of liquor, which happily mingle together, no men necessary.

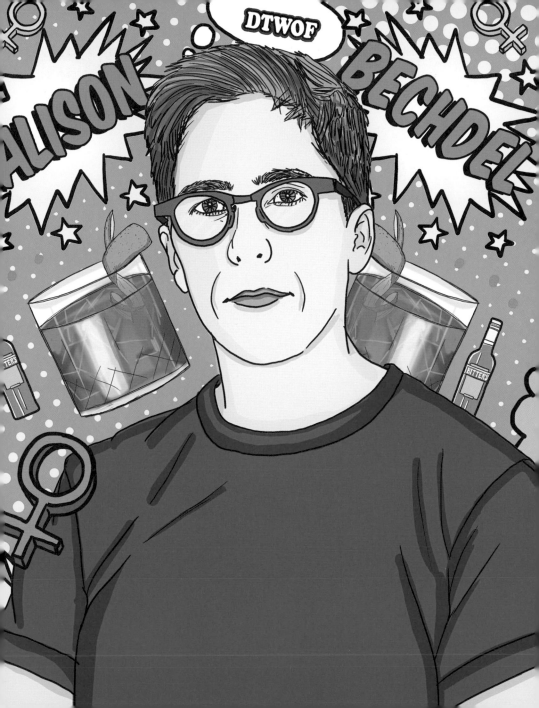

b. 1975

TANYA TAGAQ

The Tanya Tagaq

1 cup / 240 ml red wine
Simple syrup (p. 14)
1 shot Cointreau
½ shot fresh lemon juice
Garnish: *aupilaktunnguat*
 (or any purple flower)

A day beforehand, pour red wine into an ice cube tray and freeze, leaving 1 cube empty. Fill empty cube with simple syrup. Allow tray to freeze overnight.

Add the frozen wine and simple syrup to a blender with the rest of the ingredients. Pulse until blended. Serve in a rocks glass and garnish with *aupilaktunnguat*, a beautiful (and edible) purple arctic flower that grows in Nunavut, Norway, and Northern Ireland—or whatever purple flower you can find.

Tanya Tagaq's music is as powerful and ferocious as the Inuk throat singer herself. Tagaq grew up in Cambridge Bay, a tiny hamlet in Canada's northernmost territory, Nunavut. When she went to high school in Yellowknife she learned the art of throat singing, a traditional Inuit performance technique that involves a kind of guttural, rhythmic inhalation and exhalation. Tagaq soon developed her own take on the practice, and was vaulted to fame by her collaborations with Icelandic singer Björk.

While she's widely celebrated, having won the indie music nod of the Polaris Prize and claimed her country's highest honor, the Order of Canada, plus has been nominated for the Giller Prize for her 2018 debut novel, *Split Tooth*, Tagaq is a provocateur who thrives on spirited activism and championing environmental and Indigenous causes. As an Inuit woman who grew up in the Arctic, she's perhaps more aware of global warming than most. Her lyrics about the environment, involving Mother Earth's retribution, are unsparing. So are her songs about womanhood, which she links back to the earth (something she calls "wombcore"). With performances so sensual and raw, Tagaq often faces questions about her sexuality, which she answers frankly. As she told *The Walrus* magazine in 2016, "Sex to me is really sacred—and I'm really good at it."

Because she's a resident of the frozen north and in touch with her primal instincts, Tagaq would enjoy this full-bodied frozen cocktail—a red-wine slushie that's both strong and delicious.

VIRGINIA WOOLF

The Virginia Woolf

¾ shot gin
¾ shot **Green Chartreuse**
¾ shot **St-Germain**
¾ shot **fresh lime juice**
Garnish: lime twist

Add ingredients to a shaker with ice and shake. Strain into a coupe glass and garnish with a lime twist.

Brilliant and daring, Virginia Woolf was a trailblazer of modernist literature. In her fiction, she boldly experimented with narrative while, in her nonfiction, she demanded women's equality in the creative sphere.

Woolf grew up in a privileged, well-educated family, and had the means to attend King's College in London, where she befriended a number of high-profile feminists. By the time she was 23, she was writing for the *Times Literary Supplement* and palling around with the Bloomsbury Group, a circle of avant-garde artists and intellectuals. Her first novel, *Voyage Out*, was published when she was 33; she followed that with classics like *Mrs. Dalloway*, *To the Lighthouse*, and *Orlando*. Her novels played with then-unusual literary devices like free association and stream-of-consciousness. Thematically, her work delved into topics such as women's rights, mental illness, and homosexuality, all things that Woolf, a feminist who struggled with depression and had had an affair with a woman, knew intimately. Sadly, she ended up taking her own life. When she was 59 she filled the pockets of her overcoat with stones and waded into a nearby river, which swept her away.

Woolf's most famous work may be one of her essays, a tract titled "A Room of One's Own." In it, she declared that, in order to write, a woman needed her own money and her own space—things that men had without question. Her argument is still relevant today, and so Woolf's cocktail is a spin on a classic called The Last Word. This version uses the floral, pungent elderflower liqueur St-Germain.

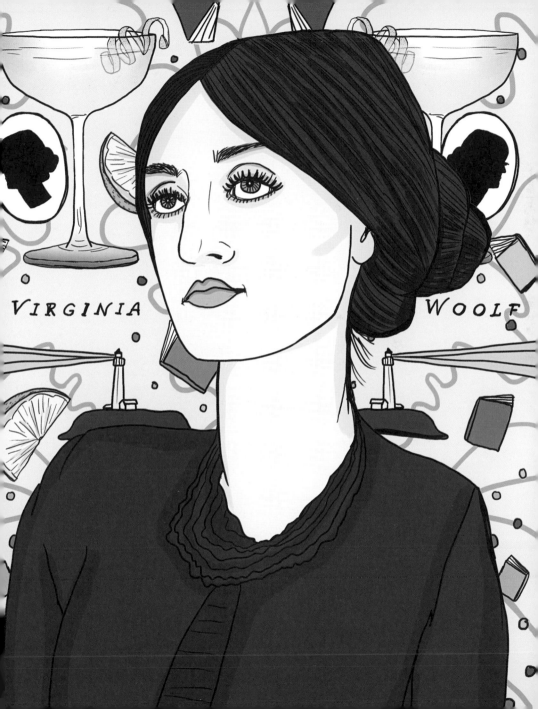

VIRGINIA WOOLF

RUPI KAUR

Rupi Kaur's powerful, raw poetry singlehandedly turned a formerly sleepy, obscure art form into something that can pack theaters with thousands of breathless fans. Dubbed "the voice of her generation," the millennial writer sells millions whenever she releases a book—a feat she accomplished entirely on her own.

In 2014, the India-born, Canada-raised Kaur began Instagramming her unpunctuated, lowercase verse illustrated with simple line drawings, inspired by Sikh scripture and poets like Kahlil Gibran and Sharon Olds. Her pieces, which unsparingly and emotionally addressed trauma and abuse, self-care, acceptance, and healing, attracted thousands of followers. She self-published her first volume of poetry, *milk and honey*, via Amazon when she was only 22. But poetry wasn't the only thing she shared online. When Instagram censored a photo of her lying on a bed wearing gray sweatpants stained with menstrual blood, Kaur's pushback turned her into a warrior against the policing of women's bodies, as well as a viral sensation. A month later, she landed a deal with a major publisher who released a second edition of *milk and honey*. It remained on the *New York Times* bestseller list for over a year. Kaur's second book, *The Sun and Her Flowers*, was a deeper, more emotional volume divided into sections reflecting the life cycle of a flower, while her third, *Home Body*, focused on the past, present, and future of the self. And 2022's *Healing Through Words* helped readers channel Kaur by exploring their identity through guided writing exercises.

Kaur's cocktail is inspired by her first book—it's literally milk and honey, both delicate and strong.

The Rupi Kaur

1½ shots gold rum
1 shot honey syrup
 (half hot water, half honey)
1 shot light cream
 (single, around 18% fat)
Garnish: honeycomb on
 a cocktail pick

Shake all ingredients in a shaker with ice. Strain into a coupe glass and garnish with a small piece of honeycomb on a cocktail pick.

40

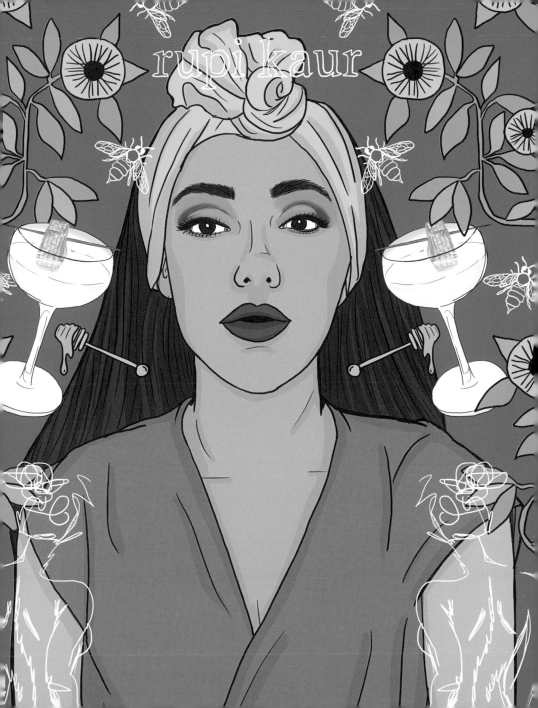

b. 1934

GLORIA STEINEM

The Gloria Steinem

2 shots Scotch whisky
(e.g. Glenfiddich)
1 shot fresh lemon juice
1 shot simple syrup (p.14)
½ shot egg white
½ shot fruity red wine

Combine ingredients (except
for red wine) in a shaker with ice
and shake for about 30 seconds.
Strain into a rocks glass partially
full of ice. Position a spoon,
curved side up, just over the glass,
and pour the red wine over it to
add a float on top of the drink.

Brilliant, charismatic, and photogenic, Gloria Steinem
became a figurehead for the women's rights movement in
the '60s. Her first big break as a journalist—at age 29—came
from penning a story for which she posed as a Bunny at the
Playboy Club in New York to expose the borderline-illegal
working conditions the women there endured. That article
almost tanked her career; people couldn't stop thinking
of her as a Bunny rather than a serious writer. But she
persevered in journalism, eventually founding *Ms.* magazine
in 1972, when she was 38. It was immediately successful,
and Steinem, as its editor, gained renown. At protests and
rallies she was a conspicuous presence, and her fashionable
look—long, center-parted hair, aviator shades, and
miniskirts—made her a style icon, too.

Today, a whole new generation of feminists has risen
up below Steinem, but she's still extremely active in the
movement. At the Women's March on Washington in 2017,
she was one of the celebrity speakers who rallied the
passionate crowd. And in 2022, after Roe v. Wade was
overturned, restricting abortion access in the US, she
proclaimed that "there is no democracy" without the
right to choose.

Steinem also once said, "Women may be the one group that
grows more radical with age." And so her drink is a classic
that uses an aged liquor as its base—with a radical twist.
Some call it a New York Sour; based on a Whiskey Sour, this
version uses Scotch rather than rye or bourbon.

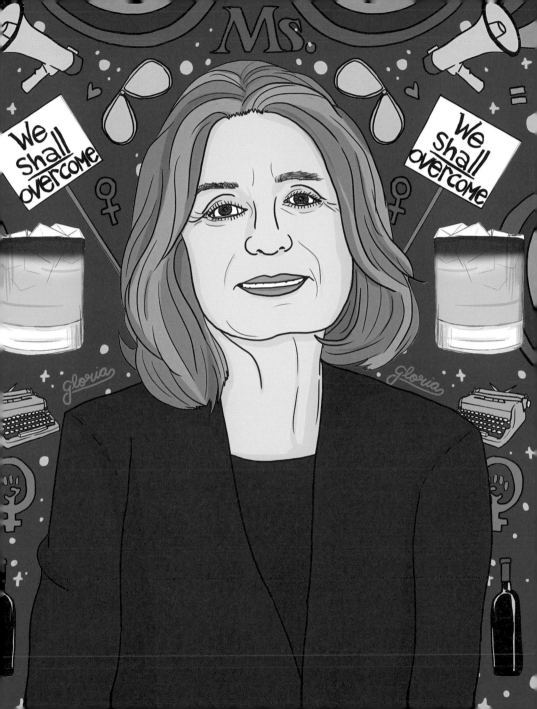

b. 1992

HARI NEF

The Hari Nef

2 shots dry vermouth
1 shot Bénédictine
3 dashes absinthe
Garnish: orange twist

Pour ingredients into a mixing glass and stir with ice. Strain into a chilled cocktail glass and garnish with an orange twist.

With her nonchalance and brooding beauty, model and actor Hari Nef is the New York cool girl of our era. She transfixed the fashion world in 2015 when she became the first openly-transgender woman to sign a major modeling contract, with IMG, and walked the runway at New York Fashion Week. That same year, she rose to prominence as an actress, too, in her role as a glamorous young trans woman in Weimar-era Berlin on the television show *Transparent*. Over the years, Nef has coolly balanced success on the catwalk and onscreen, modeling for brands like Gucci and Eckhaus Latta and appearing in both mainstream and indie films and TV productions; in 2023, she starred in Abel "The Weeknd" Tesfaye's television show *The Idol* and signed on to play the titular role in a biopic about Warhol superstar Candy Darling. Of the latter, Nef commented on Instagram, "She taught girls like me how to dream—perhaps even how to be at all."

While some may want Nef to be an activist, she refuses to let gender be her most notable feature and pushes back against typecasting. "Identity is a dead end. It's a snoozefest," she told *The Guardian* in 2016.

Nef's casual rejection of the unchill deserves a cocktail that's the antithesis of basic: a spin on the Chrysanthemum, a simple drink with complex flavors that's easy to make, but hard to pin down.

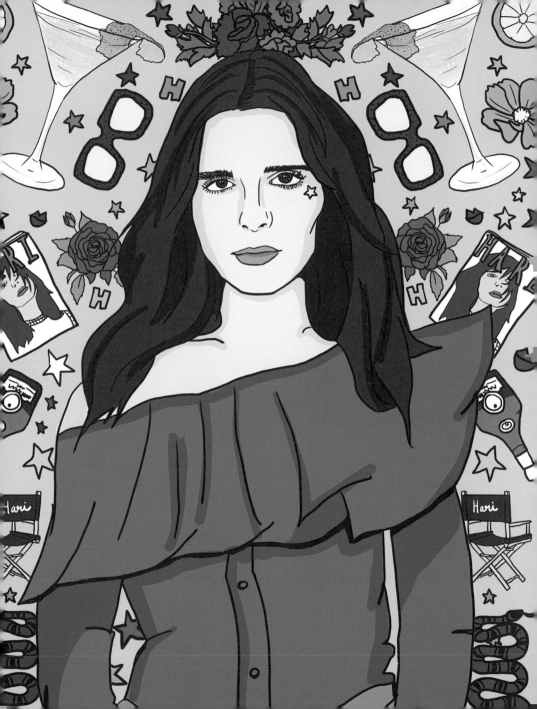

MISSY ELLIOTT

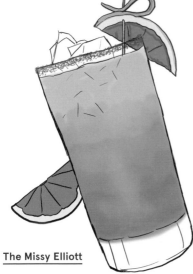

The Missy Elliott

1 tbsp cayenne
1 tbsp salt
1 ruby red grapefruit
1½ shots vodka
1 dash maraschino liqueur
Garnish: grapefruit wedge

On a small plate, mix cayenne and salt. Using a slice of grapefruit, moisten the rim of a highball glass. Dip the glass into the salt mix and twist to rim the glass. Fill the glass with ice, pour vodka and maraschino in, and top with freshly-squeezed grapefruit juice. Garnish with a grapefruit wedge.

Missy "Misdemeanor" Elliott's sound is unmistakable: clever, raunchy, and confident as eff. She's been a platinum-selling rapper since her debut album, *Supa Dupa Fly*, was released in 1997, and her style is just as fresh today. Before she became a star Missy worked behind the scenes, collaborating with her best friend Timbaland to write and produce for the likes of Destiny's Child and Aaliyah, and occasionally dropped a guest verse for rappers including Puff Daddy and MC Lyte. Puffy wanted to sign her to his Bad Boy label, but Elliott chose to maintain artistic independence by starting her own imprint, The Goldmind Inc., with Elektra. The rest is history: from 1997 to 2006 she was the queen of rap, holding her own in a scene that was male-dominated and often openly misogynistic (gripes about "bitches" and "hoes" were frequent in rap lyrics). Part of Elliott's appeal came from her unwavering self-confidence: she didn't have the vixen-ish body of a pop star, and she'd appear in videos wearing tracksuits, rapping saucily about sex. She was the subject of her own rap fantasies and, in turn, never allowed herself to be objectified.

Elliott went on a long hiatus but, in 2015, re-emerged in a surprise Super Bowl performance—and nearly broke the internet. Later that same year, she came out with a comeback track, "WTF (Where They From)," and in 2019, released *Iconology*, her first album in 15 years.

To celebrate her return, Missy needs a saucy vodka cocktail. This spin on a Salty Dog has some staying power, like the queen of rap herself.

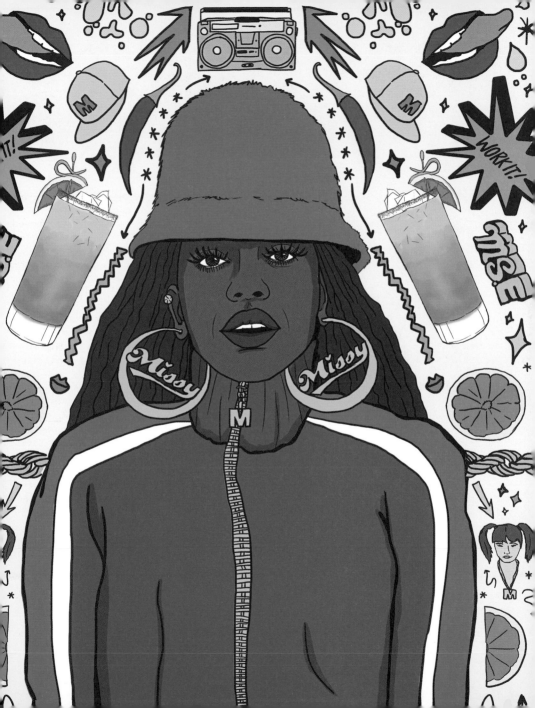

NADYA TOLOKONNIKOVA

A cacophony of brightly-colored balaclavas, neon dresses, tights, and fists raised in the air: the imagery of Pussy Riot is impossible to ignore. So is their message of resistance. As the most prominent member of the feminist punk collective, Nadya Tolokonnikova has become the ambassador for a protest movement that is unmistakably punk, and essentially female.

Tolokonnikova's agitation began in earnest after she started studying at Moscow University, where she joined a political performance art cooperative named Voina. But it was the the group she co-founded after this, Pussy Riot, that turned her into an international champion for human rights. Part performance art, part rock band, Pussy Riot staged public happenings as a form of protest; their most famous, at Moscow Cathedral, nicknamed the "Punk Prayer," involved a rapid-fire guerrilla show of hard-hitting songs decrying the rule of Vladimir Putin. Afterward, when Tolokonnikova and two other members of the group were thrown in jail, supporters around the world put on balaclavas, dresses, and tights and demonstrated for their release, and the outfit became a symbol of female resistance. The three were eventually freed, and today Tolokonnikova is still a force to be reckoned with, campaigning for prison reform, recording new music with Pussy Riot, and in 2022, continuing to speak out against Putin's repressive regime and helping fundraise for Ukraine's defense against the Russian invasion of their country.

Tolokonnikova's cocktail is a Moscow Mule with an added kick from jalapeño-infused vodka—spicy enough to spark your revolutionary fervor.

The Nadya Tolokonnikova

For the jalapeño-infused vodka
1 jalapeño pepper
1 cup / 240 ml vodka

Place chopped jalapeño pepper in a container with a lid (for less spice, leave out the seeds). Top with vodka and allow to sit for 3 to 4 hours.

For the cocktail
½ shot fresh lime juice
2 shots jalapeño-infused vodka
Ginger beer
Garnish: lime round

Pour lime juice into a Moscow Mule mug (or Collins glass) and throw in the rind. Add ice, pour in vodka, and top with ginger beer. Garnish with a lime round.

48

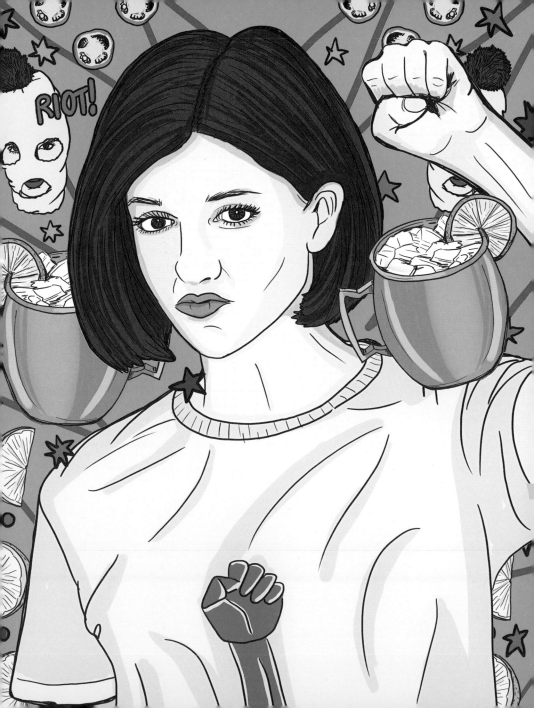

b. 1942

REI KAWAKUBO

The Rei Kawakubo

1½ shots light rum
1 shot simple syrup (p. 14)
½ shot fresh lemon juice
½ shot fresh lime juice
¼ shot maraschino liqueur
¼ tsp activated charcoal*
Garnish: lemon twist

**Add all ingredients to a shaker
with ice, shake for a minute, and
strain into a coupe glass. Garnish
with a lemon twist.**

*Note: activated charcoal absorbs
toxins—but it absorbs medicine, too.
If you're on any medications (including
the Pill), be careful with this one.

Before Rei Kawakubo, fashion was often pretty. But her torn, lumpy, misshapen, confrontational designs changed all that: suddenly, ugly was chic.

Kawakubo didn't plan to work in fashion. After attending university in Tokyo, where she studied the history of aesthetics, she got a job in the advertising department of a textile manufacturer. She put together props and costumes for ads, and eventually went freelance as a stylist. Whenever she couldn't find the right outfit for a project she'd create it herself, becoming a self-taught clothing designer. Soon, she had her own label, which she called Comme des Garçons (French for "like boys"). It became popular in Japan, but it wasn't until Kawakubo showed at Paris Fashion Week in the early '80s that her designs caught the attention of an international audience. Her aggressively ragged, monochromatic, distorted pieces both disturbed and delighted the press: they called the collection "apocalyptic" and "post-atomic." And back home in Japan, fans of Comme des Garçons became known as "The Crows" for their dark, brooding silhouettes.

Since then, Kawakubo has continued to push boundaries and reshape fashion with collections that defy conventional taste. Dresses with large, removable humps that make wearers appear deformed, and outfits that look more like pieces of furniture than clothing—nothing is off-limits. Kawakubo thrives on being misconstrued: "I do not feel happy when a collection is understood too well," she once said.

Like Kawakubo's clothing, her cocktail is only for the brave. It includes activated charcoal, which turns the liquid a beautiful, deep black.

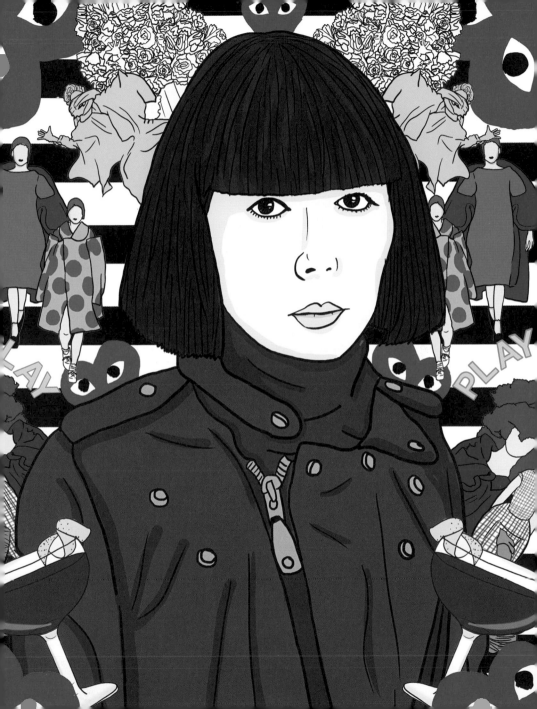

JANE GOODALL

The Jane Goodall

2 shots light rum
½ banana
1 shot Cointreau
1 shot fresh lime juice
1 tsp agave syrup
Garnish: lime wedge

Add all ingredients to a blender with ½ cup / 100 g ice and blend until smooth. Pour into a Hurricane glass and garnish with a lime wedge and straw.

Pioneering primatologist Jane Goodall has forever changed the way human beings look at chimpanzees—and themselves. Her fascination with animals began during her childhood in London, when she received a stuffed toy chimp from her father. At age 23 she moved to Kenya on her own, with no post-secondary education. She ended up being hired as a secretary to the well-known scientist Louis Leakey, who sent her to the Tanzanian jungle to study chimpanzees in the most up-close and personal way possible: by living among them.

Because Goodall hadn't formally trained as a scientist, she wasn't constrained by the controlled and methodical ways in which they usually worked. She developed her own techniques for blending in to chimp society, mimicking their behaviors, and offering them bananas if they came close, establishing what she called a "banana club." Rather than identifying chimpanzees by number, she gave them names, like Flo, Mike, and Gigi. Goodall's closeness to the chimps allowed her to observe their complex social structures and communication skills—"It isn't only human beings who have personality, who are capable of rational thought [and] emotions like joy and sorrow," she later related. When she recorded how chimps used twigs to capture termites, it overthrew the established idea that humankind could be separated from animals by our unique toolmaking ability. Profoundly altered by her experience, Goodall went on to devote the rest of her life to conservation—particularly chimpanzee welfare.

As a member of the banana club, Goodall would enjoy a drink that involves her favorite fruit. This drink, a Banana Daiquiri, is sure to facilitate observations of your fellow primates.

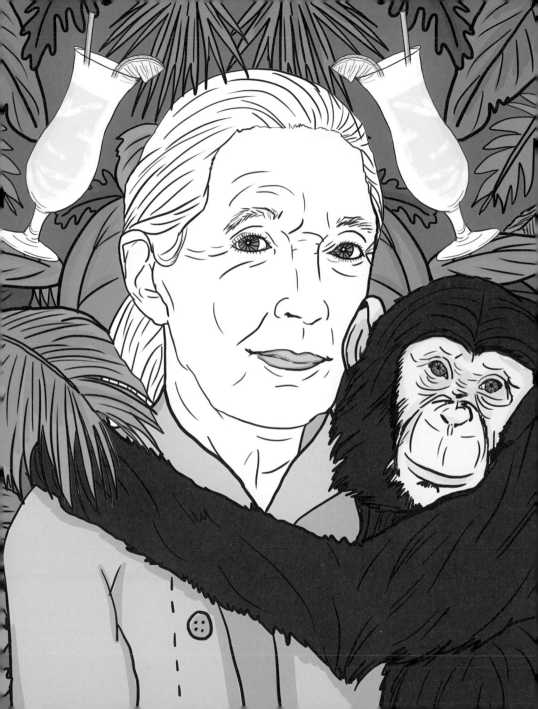

JOSEPHINE BAKER

In 1920s Jazz Age Paris, nobody could stop talking about Josephine Baker, the doe-eyed dancer whose wild, half-naked gyrations earned her the nickname "Black Venus." Her bold sensuality and steadfast fight for Black equality have made her a hero for generations of women.

Baker dreamed big from an early age. At 13 she ran away from a life of poverty in St. Louis, Missouri, eventually landing in New York, where she became a chorus line dancer at a hot club in Harlem. But true stardom lay in Paris, which, at the time, was obsessed with American jazz. She moved there in 1925 and became massively popular for two dances: the "Danse Sauvage," which she performed topless in a feather skirt, and "La Folie du Jour," involving a skirt made of bananas. Baker's star power was so great that she counted Pablo Picasso and Ernest Hemingway among her friends; off-stage, she wore couture pieces from designers such as Dior and Chanel. She reportedly received thousands of marriage proposals from admirers. During World War II Baker used her renown to fight fascism, working for the French Resistance by using her sheet music to smuggle messages (sometimes, she even hid them in her underwear). After the war, when she performed back in the US, she refused to dance for segregated audiences, becoming an equal rights activist in the process.

The Josephine Baker

1½ shots cognac
1½ shots port
1 shot apricot brandy
¼ shot simple syrup (p. 14)
Lemon zest
1 egg yolk
Garnish: cinnamon

Shake all ingredients with ice and strain into a cocktail glass. Sprinkle cinnamon on top to garnish.

Baker's erotic, seductive stylings and massive celebrity during the height of 1930s cocktail culture made her an obvious inspiration for a signature drink and, indeed, the Bar Florida in Havana, Cuba, named one after her in 1937. This is that recipe.

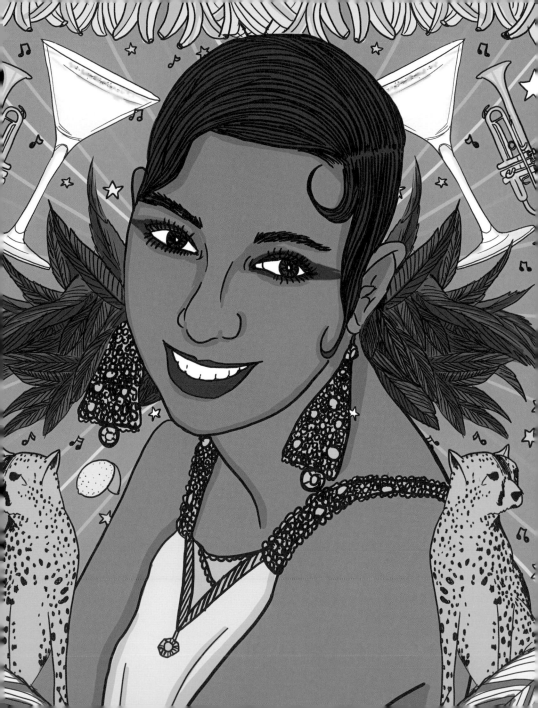

KATHLEEN HANNA

The Kathleen Hanna

1 shot silver tequila
1 shot simple syrup (p. 14)
1 shot fresh ruby red grapefruit juice
Lager
Garnish: grapefruit twist

Pour tequila, simple syrup, and
grapefruit juice into a highball
glass full of ice. Top with lager
and stir very gently to mix
(it will foam, so be careful).
Serve with a grapefruit twist.

"Girls to the front!" Kathleen Hanna used to yell these four words at Bikini Kill shows, ensuring female fans of her seminal riot grrrl band had a decent (and safe) view of the stage by getting the guys the hell out of the way. And that's what her music did, too: it gave women a space of their own within male-dominated punk culture.

Before she became a charismatic frontwoman, Hanna spent most of her formative years in the Pacific Northwest, growing up in Portland, Oregon, and moving to Olympia, Washington, to attend Evergreen State College. There, in the late '80s, she began playing in punk bands and making zines, including one called *Riot Grrrl*, a tract that became the namesake for the female-centered DIY movement that helped define third-wave feminism in the '90s. Around the same time, she joined Bikini Kill. With her brash posturing, confrontational fashion (underwear, with the word "slut" scrawled on her stomach), and full-throated yowl, Hanna became the de facto leader of the riot grrrl crusade. She brought that same energy to later groups, too, like Le Tigre (a feminist party band) and The Julie Ruin.

Post-Bikini Kill, Hanna slowed down somewhat, partially owing to being diagnosed with Lyme disease, which she recounted in the 2013 documentary about her life, *The Punk Singer*. But nothing can keep her fiery spirit down, and, after getting an all-clear from Lyme in 2015, she continues to be a fierce feminist advocate and mesmerizing performer—even reuniting with Bikini Kill for tours beginning in 2019.

This cocktail salutes Hanna's Pacific Northwest roots with beer as its main ingredient, with some added sass from tequila and grapefruit.

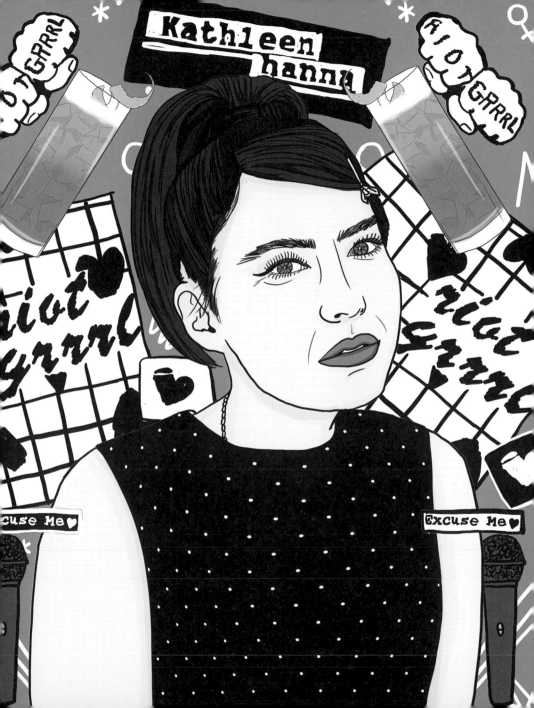

b. 1939

MARGARET ATWOOD

The Margaret Atwood

1½ shots light rum
1 shot pomegranate juice
1 shot fresh lime juice
1 shot apple juice
½ shot maraschino liqueur
Garnish: snapdragon

Add all ingredients to a shaker
and shake with ice. Pour into
a Collins glass filled with ice
and garnish with a snapdragon.

Writer Margaret Atwood is the grande dame of dystopia. Her novels tackle everything from environmental catastrophe to murder to reproductive rights, usually from the perspective of a strong female narrator.

Atwood spent much of her childhood in the deep woods outside of Ottawa, Canada, not even attending school until she was eight. But she began writing much earlier than that—at age six—and, by 16, knew she wanted to become a pro. Her first publishing successes in her early twenties were volumes of poetry, but novels are what made her a household name, beginning with *The Edible Woman*, released in 1969. A book about female alienation that coincided with the peak of second-wave feminism, it cemented her fame as a writer who spoke for women's issues.

Atwood's novels have claimed many prizes, including the Booker, which she won for *The Blind Assassin* in 2002. But she's best known for penning *The Handmaid's Tale*, the story of a world where birth rates have plummeted and a Christian fundamentalist sect has overthrown the US government. In this bleak future, a class of women called "Handmaids" are used as reproductive slaves. The characters wear red robes, a symbol of fertility. Today, due to the popular TV series (which was co-produced by Atwood), activists have worn similar robes at reproductive rights protests in the US and, owing to the eerily prescient details of her fiction, Atwood herself has been hailed as a sort of literary prophet. Reflecting that cachet, she once again won the Booker for her 2019 follow-up to *The Handmaid's Tale*, *The Testaments*.

Atwood's cocktail is the deep ruby of a Handmaid's robe, and garnished with a flower—a symbol of femininity in the Handmaids' universe and a powerful amulet.

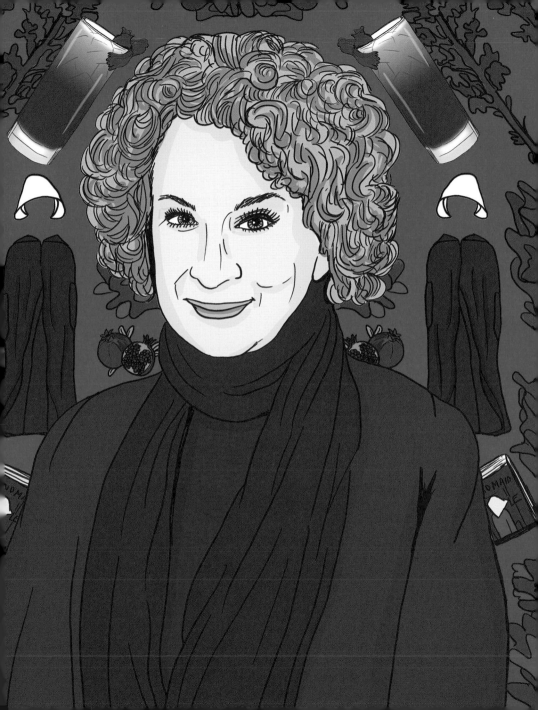

SELENA

The Selena

1½ shots silver tequila
½ shot Campari
½ shot fresh lime juice
½ shot fresh grapefruit juice
1 shot simple syrup (p. 14)
Garnish: grapefruit twist

Combine ingredients in a shaker with ice. Shake, and serve in a coupe glass with a grapefruit twist.

Few singers spark passion and emotion in listeners quite like Selena does. Nicknamed the "Queen of Tejano Music" and the "Mexican Madonna," she brought Latin music to the masses—and died tragically young.

Born Selena Quintanilla in Texas, she got her start performing in a band with two of her siblings. Called Selena y Los Dinos, they were managed by her dad and, after a few years on the wedding circuit, soon became popular. Selena, who grew up speaking English, learned Spanish in order to sing Tejano music, a kind of pop-folk that was big among Mexican Americans in Texas. Despite the fact that it was a male-dominated genre and she was sometimes refused bookings because of it, Selena became a massive star with a major record label deal. She modeled her look after Madonna, designing her own wild costumes and eventually opening clothing boutiques.

In 1995, Selena's life came to a shocking end when the manager of one of her boutiques—who was also the manager of her fan club—shot her. Her death made international news, and the public outpouring of grief was intense. Selena's funeral was attended by 60,000 mourners, and the governor of Texas (then George W. Bush) declared April 12 to be Selena Day, in honor of her birthday. Two years later, a biographical movie came out, starring Jennifer Lopez. It launched Lopez to fame, while Selena's music paved the way for the mainstream success of artists like Lopez and Shakira. In 2020, a two-season Netflix series co-created by Selena's family commemorated her life for a new generation of fans.

Selena's drink is bittersweet and strong, with a tequila base and a bit of Campari, which turns it a pretty pink.

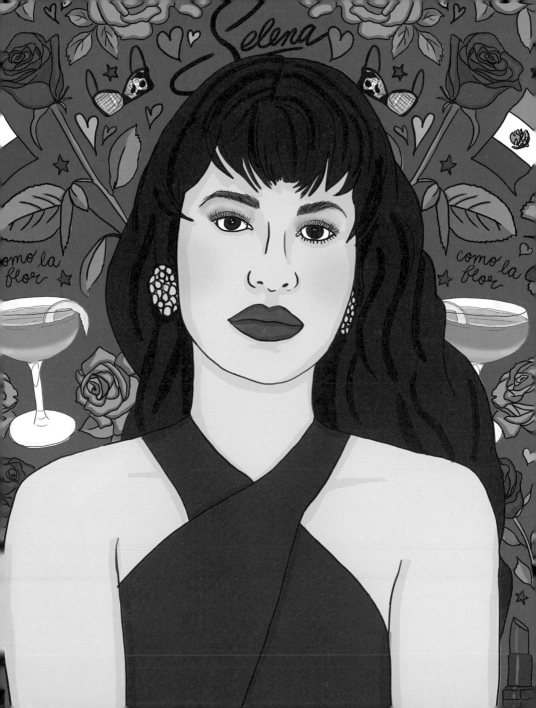

CHRISTIANE AMANPOUR

The Christiane Amanpour

1 shot vodka
1 shot Kahlua
1 shot fresh espresso
Garnish: 3 coffee beans

Add ingredients to a shaker full of ice, shake, and strain into a chilled Martini glass. Garnish with coffee beans.

Whether reporting from a rubble-filled street in the middle of a war zone or calmly dissecting global politics from behind a desk on CNN, Christiane Amanpour has delivered some of the bravest, most insightful news coverage of the last half-century.

Amanpour's journalistic style comes with a noticeable empathy for different cultures that springs from her worldly upbringing. She spent the earliest part of her childhood in Tehran, where she lived through the Iranian Revolution, before moving to London to complete her schooling at age 11. After high school, she moved to the US to study journalism and, by 1983, she was hired by what was then an upstart network: CNN. Her first assignment was covering the Iran–Iraq War, and her coverage in conflict areas, like the Persian Gulf and Bosnia, earned her a deserved reputation for fearlessness—and helped turn CNN into a force in television news. For three decades, Amanpour has been the station's chief international correspondent (with a two-year interlude at ABC), and since 2009, has hosted the interview show *Amanpour*. Since 2018, she has also hosted PBS's *Amanpour & Company*. Through it all, she has maintained an unshakeable morality. She famously said, "There are some situations one simply cannot be neutral about, because when you are neutral you are an accomplice."

Amanpour's cocktail, like the journalist herself, is the furthest thing from neutral. It's an Espresso Martini: flavorful and bold.

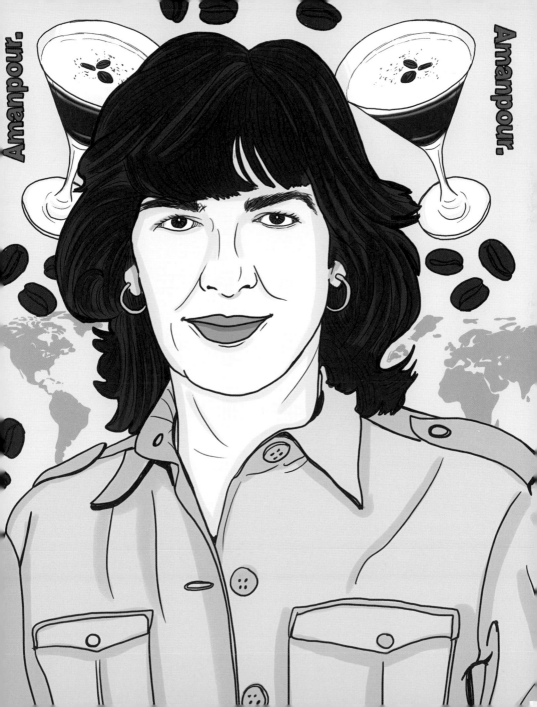

MARY TYLER MOORE

The Mary Tyler Moore

1 shot brandy
1 shot dark crème de cacao
1 shot light cream
(single, around 18% fat)
Garnish: 1 pinch freshly-grated
nutmeg

Combine ingredients in a shaker.
Shake with ice, strain into a
coupe glass, and garnish.

All the single ladies on modern television owe a debt to
Mary Tyler Moore. The funny actor with the broad smile slyly
subverted small-screen ideals of femininity with her plucky,
independent characters, pushing the representation of
women toward something more like reality.

Moore's first act of rebellion took place in the early '60s
on *The Dick Van Dyke Show*, on which she played a stay-at-
home mom. At the time, TV housewives were portrayed
as fantasies of domesticity in heels and full skirts, but Moore
balked: she wanted to look like the sort of mom that she was
herself, and so she wore capri pants. Despite the network's
complaints she kept on wearing them and they became her
character's trademark, sparking a fashion trend in the process.

More revolutionary was her eponymous program from the
'70s, *The Mary Tyler Moore Show*. She played a chipper,
go-getting television producer who was single, childless,
in her 30s—and happy. TV execs (who were mostly men at
the time) didn't have high hopes for it, but Moore—who of
course knew better what women wanted—defied expectations.
Her all-female writing staff (which would be unusual even
today!) pushed agendas by including plots about topics
like pay equity and birth control. Most importantly, Moore's
character's world didn't revolve around men, and instead
she found contentment in her career, family, and friends.
It sounds prosaic now, but back then, she was a trailblazer.

On the show's pilot episode, Moore's future boss asks her
if she'd like a drink during her job interview, and she deadpans
that she'd like a Brandy Alexander—hardly the sort of thing
he'd have in his desk drawer. Her recipe is a traditional Brandy
Alexander, which is maybe more appropriate after work than
during it.

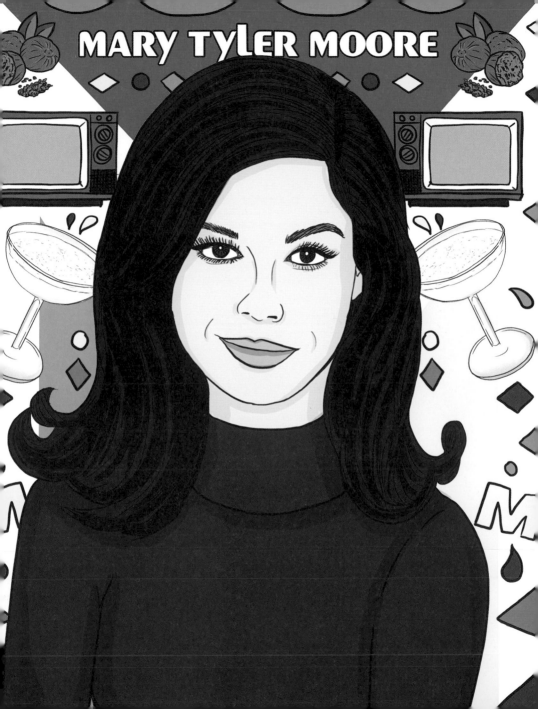

DARYL HANNAH

If you want proof that shy people can rule the world, Daryl Hannah is it. The lanky blonde actor struggled through crippling bashfulness, as well as autism, to play some of film's most memorable misfits, villains, and mythical creatures—and, in her spare time, became a tough-as-nails climate change activist.

As a child, Hannah was extremely inhibited and suffered from insomnia, often rocking back and forth to soothe her social anxiety. Eventually, doctors diagnosed her as autistic, and recommended she be institutionalized. But Hannah's mother didn't follow that advice, and Hannah found other ways to cope: one of her refuges, especially when she couldn't sleep, was movies. At age 17, she left home to star in them. The third film she appeared in, *Blade Runner*, was a massive hit, and Hannah, who played a misunderstood android named Pris who begins to develop human feelings, became a star. Her other successes included the role of a mermaid in *Splash!*, a prehistoric human in *The Clan of the Cave Bear,* and, later, a deadly, one-eyed assassin in *Kill Bill*. Though she was adored by fans, she still struggled with her disorder; when Hannah had to walk a red carpet she'd tremble with fear, and once even fainted on the set of the *Late Show with David Letterman*.

Today, Hannah is known as much for her film roles as for her unwavering defense of our climate. Her protests in support of food security and against pipelines have landed her in jail, but Hannah refuses to back down.

Her cocktail is strong, unusual, and often underestimated: a Bloody Mary.

The Daryl Hannah

1½ shots vodka
3 shots tomato juice
½ shot fresh lemon juice
1 dash Worcestershire sauce
Pinch celery salt
Pinch ground pepper
Hot sauce to taste
Horseradish to taste
Garnish: 2 stalks pickled asparagus
 and a lemon wedge

Add all ingredients to a Mason jar full of ice and stir until mixed. Garnish with pickled asparagus and a lemon wedge.

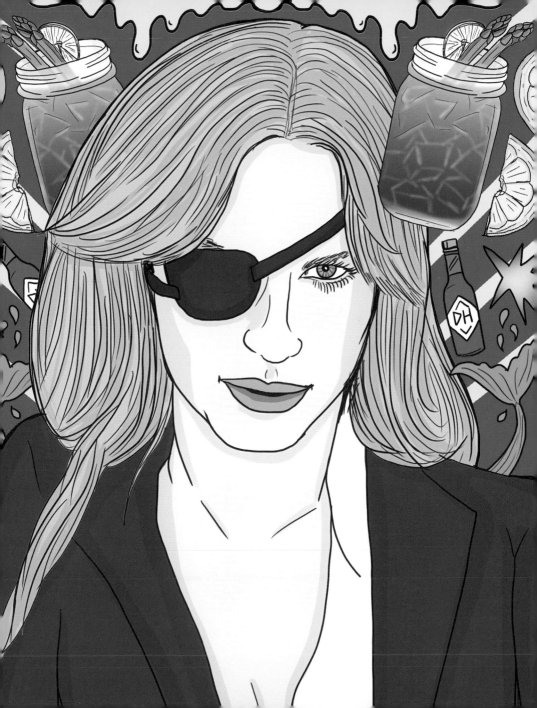

MAYA ANGELOU

Memoirist, poet, and activist Maya Angelou is a luminary of 20th-century literature, and for good reason. As one of the first Black writers to use her own life as source material, she became a de facto spokesperson for African Americans' lived experiences in the process.

Angelou's early career was varied. She got her start as a dancer, which prompted a name change (from the more sedate Marguerite Johnson) to better capture the energy of her performances. She toured in the cast of the opera *Porgy and Bess*, and even released an album of calypso songs. In 1959, she moved to New York, where she became part of the Harlem Writers Guild and took a position as a coordinator for the Southern Christian Leadership Conference, where she worked with Martin Luther King, Jr. Ten years later she published her first memoir, *I Know Why the Caged Bird Sings*, a coming-of-age story that chronicled how Angelou used her love of books to triumph over the racism, sexual abuse, and trauma she experienced growing up. It was a massive success that propelled her to stardom, paving the way for a further six memoirs. She was a prolific poet, too, and her verse, which earned her the sobriquet "the Black woman's Poet Laureate," was nominated for a Pulitzer Prize. In 1993, she was the first African American—and the second poet—to read at a presidential inauguration, for Bill Clinton. The recording of that poem won her a Grammy.

The Maya Angelou

1½ shots gin
½ shot cream sherry
¾ shot fresh lemon juice
½ shot simple syrup (p. 14)
1 fresh egg white
2 shots club soda (soda water)
Garnish: lemon twist

Add all ingredients, except club soda, to a shaker and dry shake without ice for 10 seconds. Add ice cubes and shake for an additional 10 seconds. Strain into an ice-filled Collins glass, top with the soda, and garnish with a lemon twist.

Angelou's writing routine involved beginning work at about 5:30 a.m., and then, sometime along the way—usually by 11 a.m.—pouring herself a glass of sherry. Her cocktail is a sherry Gin Fizz: refined, drinkable, and inspiring.

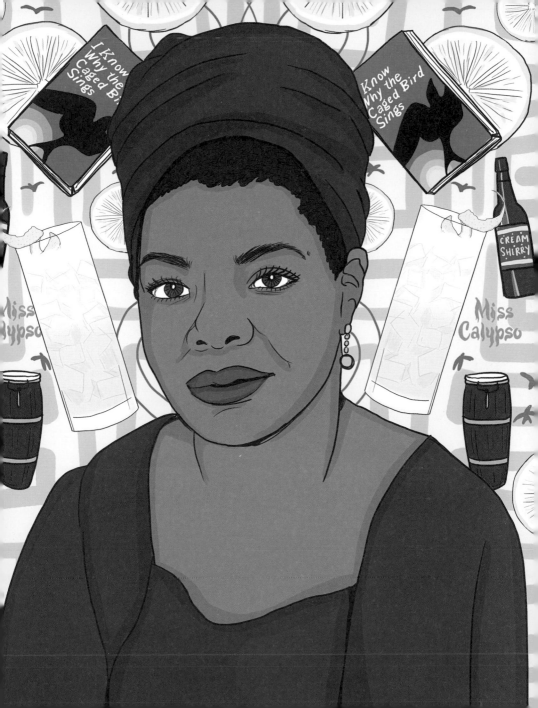

CINDY SHERMAN

The Cindy Sherman

2 shots vodka
1 shot cranberry juice
¾ shot fresh lime juice
¾ shot triple sec
Garnish: lemon twist

Shake all ingredients in a cocktail shaker full of ice and then strain through a fine strainer into a chilled Martini glass. Garnish with a lemon twist.

Cindy Sherman is a master of disguise. The New Jersey-born photographer's shapeshifting self-portraits, which transform her into clowns, socialites, movie stars, and misfits, challenge traditional ideas about beauty.

When Sherman went to art school in the early '70s, painting was the dominant medium, and excelling at it was what led to acceptance in the fine art sphere. However, she felt stifled by this conservatism, and picked up a camera instead. Her first exhibition after graduating was *Untitled Film Stills*, a collection of 69 black-and-white photos that took on the clichés of women's film roles in the '50s and '60s. Sherman's subject was herself: using costumes and makeup, she'd mutate into stereotypical female characters, a process that simultaneously erased her own identity and confronted the ridiculousness of social norms. Her work struck a chord with audiences and critics alike because it was feminist, it was postmodern, and it highlighted the ways that photography could distort reality.

In Sherman's later work, she dressed up as centerfolds, historical figures, and characters from fairytales, and used plastic doll parts to construct the grotesque *Sex Pictures*, all of which confronted the objectification of women. More recently, she has experimented with Instagram selfies— warped artistic creations that take filters to a new level. Even as the camera's focus, Sherman gives away little about herself. She's rarely recognized on the street because, after all, most people don't know what she truly looks like.

If you can imagine Sherman drinking a cocktail, it would have to be a Cosmopolitan—it's the most stereotypically girly drink, which is what makes it subversive.

b. 1966

PEACHES

The Peaches

For the peach puree
1 ripe peach
1 tsp fresh lemon juice
1 tbsp sugar

Peel and core peach and combine with lemon juice and sugar in a blender. Blend until smooth, and strain.

For the cocktail
1 shot peach puree
Prosecco
Garnish: peach slice

Pour peach puree into a champagne flute and top up with prosecco. Garnish with a peach slice. (This recipe works best when peaches are ripe and in season; if you can't find a ripe peach, you can substitute 1 shot of Italian peach nectar for the fresh peach puree.)

Sex-positive electroclash pioneer Peaches refuses to remain inside the box. Before becoming a successful musician, she was a schoolteacher in Toronto. In her early years in that city's indie scene, Peaches collaborated with her then-roommate, the singer-songwriter Feist, who performed at Peaches' live shows with a sock puppet. In 2000, she visited her musician friend Chilly Gonzales in Berlin, deciding to live there permanently. She was soon signed to the label Kitty-Yo and found fame, at age 3 with her pulsating, lo-fi dance hit "Fuck the Pain Away," which featured a growling, lustful claim to having sex for the fun of it.

In the years since, she's remained a provocateur and queer ico known for fiercely-uncompromising views on female sexuality, owing to albums like *Fatherfucker*, *Impeach My Bush*, *I Feel Cream*, and *Rub*. Her work involves equal doses of musicality and performance art. Peaches parades around on stage in bizarre metallic tracksuits, underwear, or even less, and her album covers and music videos are no less transgressive; her NSFW video for "Rub" features an array of diverse bodies in various states of undress, and a whole lot of what she calls "hairy pussies."

While Peaches still remains somewhat underground, a whole generation of stars owe their edge to her: it's hard to imagine Lady Gaga or Miley Cyrus without her influence. And her music brings tough-girl cred to other feminist performers and artists; prime example is her song "Boys Want to Be Her," which was the theme to late-night talk show *Full Frontal with Samantha Bee*. In 2023, new fans exploring early aughts culture joined the legions who grew up with electroclash to celebrate Peaches' sex-positive bangers at a 20th anniversary tour for *The Teaches of Peaches*.

After a night of fun, Peaches might enjoy this traditional Bellini a delicious breakfast drink featuring fresh peach juice.

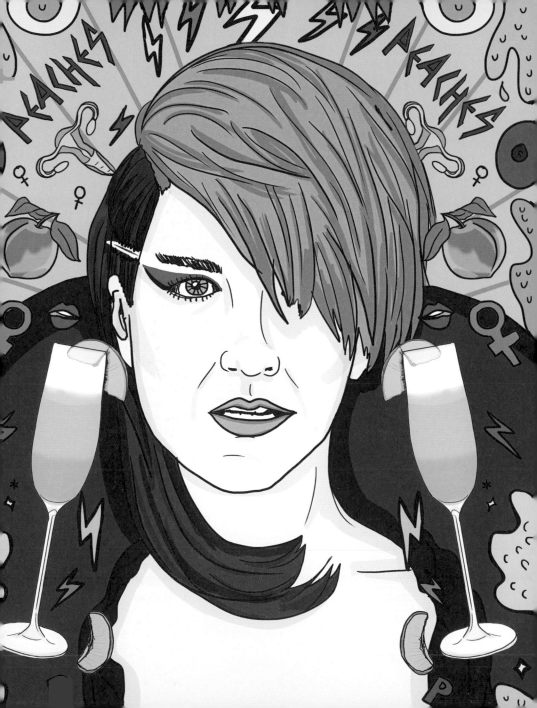

ANNA PAVLOVA

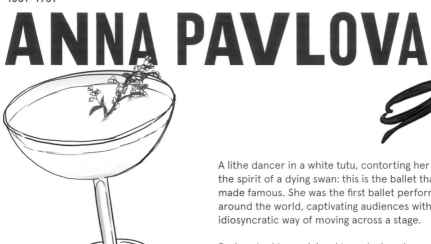

The Anna Pavlova

2 shots vodka
1 shot fresh lemon juice
1 shot simple syrup (p. 14)
1 egg white
2 dashes vanilla
Garnish: baby's breath

Add all ingredients to a shaker
and shake with ice. Strain into
a coupe glass and garnish with
baby's breath.

A lithe dancer in a white tutu, contorting her body to channel
the spirit of a dying swan: this is the ballet that Anna Pavlova
made famous. She was the first ballet performer to tour
around the world, captivating audiences with her artistic,
idiosyncratic way of moving across a stage.

Pavlova had to work hard to make her dreams come true.
She grew up poor in Russia, but when her mother found the
money to take her to a ballet, she immediately fell in love with
the art form. She enrolled in a dance school soon after, at
age 10. However, she didn't fit the classic mold for a ballerina.
Pavlova was taller and lankier than most of her peers, while
her feet were severely arched and her ankles thin. But she
devoted herself to practicing and, when she graduated,
was chosen for the Imperial Ballet in St. Petersburg. By the
time she was 25, she was named prima ballerina.

To the shock and delight of audiences, Pavlova broke all the
rules of ballet. She performed with bent knees and turned
out her feet imprecisely—rather than strict and disciplined,
her motions were romantic and interpretive. She brought
this creative energy to the role of "The Dying Swan," a dance
she commissioned and which she performed more than
4,000 times throughout her life. In the wake of her success,
Pavlova boldly formed her own ballet company, an act that
allowed her to maintain control over her performances as
she toured.

Her drink is light and delicate, capturing the moody beauty
of her famous swan.

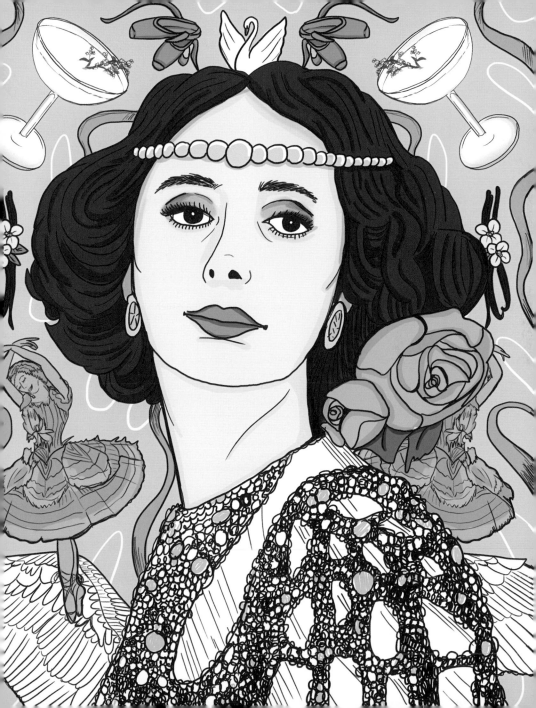

LUCILLE BALL

America's crush on Lucille Ball lasted for much of the 20th century. But Lucy was more than just loved: she was a television trailblazer, charming audiences onscreen while breaking barriers as a woman in Hollywood behind the scenes.

Ball's first gig was as a model when she was 18 years old. Over the next few years she began to appear in movies as a chorus girl and, when she was 30, met a Cuban band leader named Desi Arnaz. Sparks flew, and the two eloped. She continued to nab roles in low-budget pictures, earning the nickname "Queen of the Bs." But Ball—who by this point had dyed her hair its signature red—became known for her skills as a physical comic, leading to her being cast in a central role on a TV show on which she insisted Arnaz be her costar. *I Love Lucy* became massively popular, finally making Ball a household name at age 40. The program boasted many firsts—an interracial marriage, a live studio audience—but one of the most notable was Ball's onscreen pregnancy two years into its run. This was considered scandalous at the time, and she wasn't even allowed to use the world "pregnant"—instead, the network made her say "expecting."

Ball's influence on television went beyond her screen presence: she and Arnaz formed a production company, Desilu, which she took over after their eventual divorce. She developed major shows like *The Untouchables* and *Star Trek* and, until 1962, Desilu was the second-largest independent television production company in the US—with Ball as the very first woman to helm a major studio. (In 2021, a new generation was introduced to Ball's story in the film *Being the Ricardos*, with Nicole Kidman in the lead role.)

Ball's cocktail is a sweet frosé—light, refreshing, and the same color as her strawberry locks.

The Lucille Ball
Serves 4

For the strawberry syrup
½ cup / 100 g sugar
5 large strawberries,
 hulled and quartered

Bring sugar and ½ cup / 120 ml water to a boil. Take off heat. Add strawberries and bring to a simmer for 5 minutes. Strain to remove the strawberry chunks (you can save these for something else!).

For the cocktail
1 750 ml bottle rosé
2 shots vodka
2 shots strawberry syrup
2 shots fresh lemon juice
Garnish: fresh strawberry

Pour rosé into ice cube trays and freeze overnight. In a blender, add rosé cubes, vodka, strawberry syrup, and lemon juice. Blend for 2 minutes, until smooth. Pour into a wine glass and garnish with a fresh strawberry.

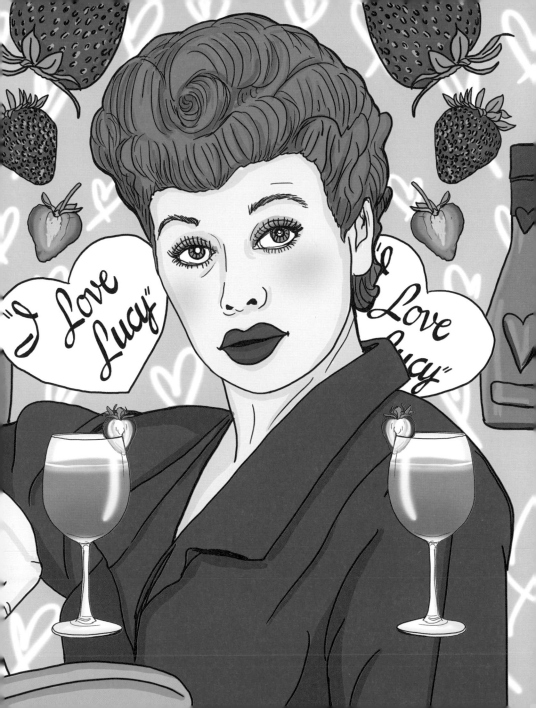

b. 1929

YAYOI KUSAMA

The shimmery, cosmic otherworldliness of Yayoi Kusama's *Infinity Mirrors* installations has been inundating Instagram for what feels like forever, but this experimental artist's work is a cut above meme-worthy—she's been a force shaping Pop and feminist art since the '50s.

As a young child growing up in Japan, Kusama experienced strange hallucinations, describing them as "flashes of light, auras, or dense fields of dots." She turned her affliction into art, and these patterns became a recurring motif in her work. Kusama first attained fame for her paintings covered with spots, about which she said, "Polka dots are a way to infinity." In the late '50s, she moved to New York and became a leader of the avant-garde art movement. She created wild exhibitions featuring entire rooms sprouting with phallic obtrusions and staged happenings, including one in 1969 called *Grand Orgy to Awaken the Dead* at MoMA, where she painted polka dots on the naked bodies of participants.

In the late '70s, Kusama voluntarily checked herself in to a mental hospital in Tokyo owing to her ongoing hallucinations. She still resides there to this day, but produces art at a studio across the street and shows it around the world. She is one of the most popular artists alive today, and her museum shows—which she attends dressed in quirky polka-dot ensembles and brightly-colored wigs—attract crowds in the millions.

Kusama's drink is unconventional, weird, and pretty, just like her work. A champagne Jell-O shot (jelly shot) covered in polka-dot sprinkles, it's a delicious little taste of infinity.

The Yayoi Kusama
Makes 10–16 depending on size

1¾ cups / 420 ml champagne (divided)
1 tbsp fresh lemon juice
1 tbsp sugar
3 envelopes gelatin
rainbow sprinkles

In a pot, combine 1¼ cups / 360 ml champagne, lemon juice, and sugar. Sprinkle gelatin on top, allowing to soften for 2 to 3 minutes. Heat mixture gently, stirring for about 2 to 3 minutes, until gelatin has dissolved. Stir in remaining ½ cup champagne.

Pour mixture into a mini muffin tin sprayed with nonstick cooking oil or, if you don't have one of those, into paper single-serving drink cups. Fill to desired height—shots can be bigger or smaller depending on your taste. Put in fridge and allow to cool for 2 hours, until solid. Invert tray or paper cups onto parchment paper to remove shots (if they stick to the paper cups, you can cut the cups off). Dip each shot in sprinkles and serve.

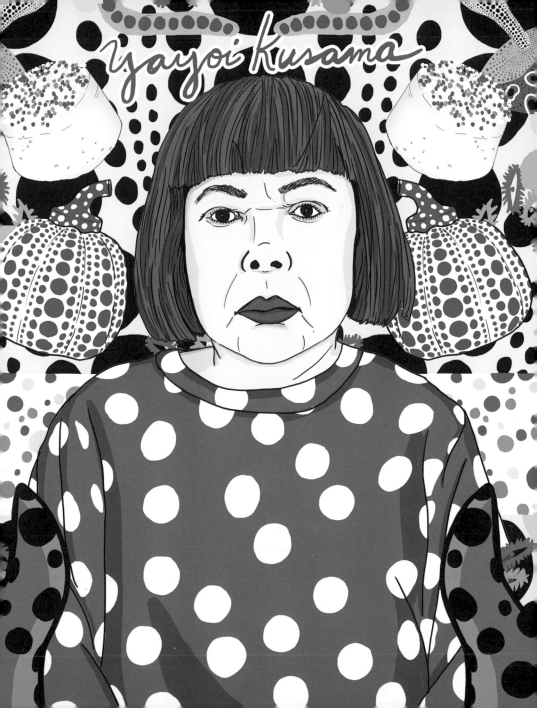

ANAÏS NIN

The Anaïs Nin

2½ shots gin
½ shot extra-dry vermouth
2 dashes orange bitters
Garnish: orange twist

Combine ingredients in a cocktail shaker with cracked ice. Stir, and strain into a chilled Martini glass. Garnish with an orange twist.

Writer and literary world *enfant terrible* Anaïs Nin was sex positive before sex positivity had a name. Born in France to Cuban parents, she married rich, and used her wealth to sponsor emerging writers—famously, she had a steamy affair with Henry Miller and bankrolled his early career (steamy affairs with other writers were an ongoing feature of her life).

For years, Nin didn't receive the professional respect she deserved. She had to self-publish many of her books, going so far as to work the printing press herself. A number of them were critically mocked; some were dismissed as pornographic. She didn't achieve mainstream success until age 63 when she published her diaries, which combined detailed accounts of her life with philosophical ruminations. They made her a feminist hero, and today, Nin's quotes are Instagram meme gold. Posthumously, she became infamous after several volumes of erotica she'd written 30 years earlier were published. Her licentious reputation was enhanced by uncensored versions of her diaries that included explicit descriptions of sex with people like Miller. But as a woman writing about sex from a female perspective, Nin was a pioneer; even by today's standards, her work seems daring.

In her diaries, she wrote, "A Martini makes an ordinary glass shine like a diamond, makes an iron bed in Mexico seem like the feather bed of a sultan." Leave it up to Nin, whose diaries elevated mundane acts to rites of passion, to make a simple Martini sound like something that could save your life. This version uses orange bitters, which were common when she was young.

BETH DITTO

The Beth Ditto

1 cup / 240 ml black tea
1 tbsp sugar
1 lemon
Mint leaves
1½ shots bourbon
½ shot Cointreau
Garnish: mint sprigs

Make tea, and mix in sugar. Allow to cool. In a medium-sized Mason jar, muddle sliced lemon and a few mint leaves. Fill glass with ice, pour in bourbon and Cointreau, and top with cool tea. Garnish with many sprigs of mint.

Pride is Beth Ditto's flashiest accessory. The singer-songwriter whose pipes made dance-rock band The Gossip famous has described herself as a "fat, feminist lesbian from Arkansas," and whether she's on stage or in a crowd, she doesn't bow to the pressure to blend in.

Ditto grew up dirt poor in a large, religious family who, despite living in a very conservative part of the US, supported her when she came out as bi at 15, and then as a lesbian at 18. At that age, she moved with friends to Olympia, Washington—the small coastal city where riot grrrl was born. It was the perfect environment in which to nurture The Gossip, the brash, provocative group that she fronted from 1999 to 2016. "Standing in the Way of Control," a ferociously-powerful gay rights anthem, catapulted the band to stardom in 2006. In the years after that, Ditto became known not only as a mesmerizing performer and outspoken queer rights activist but as a trailblazer for the body positivity movement. When she appeared naked and resplendent on the cover of *LOVE* magazine in 2007, it blew people's minds: Ditto's body was so different from the narrow beauty standards normally dictated by magazines. "Maybe people will see a body like mine and then remember that we are actually the norm," she said of the photo. She became a fashion inspiration, too, known for wearing loud patterns, bright colors, and outré designs. Mainstream designers took notice, and she walked as a model for the likes of Jean Paul Gaultier and Marc Jacobs. In recent years, she officially became a triple threat, establishing herself as an actress in TV shows like *On Becoming a God in Central Florida* and *Monarch*.

Ditto's drink is a spiked iced tea, guaranteed to quench your thirst in the heat of an Arkansas summer—and, with its showy mint garnish, sure to catch the attention, too.

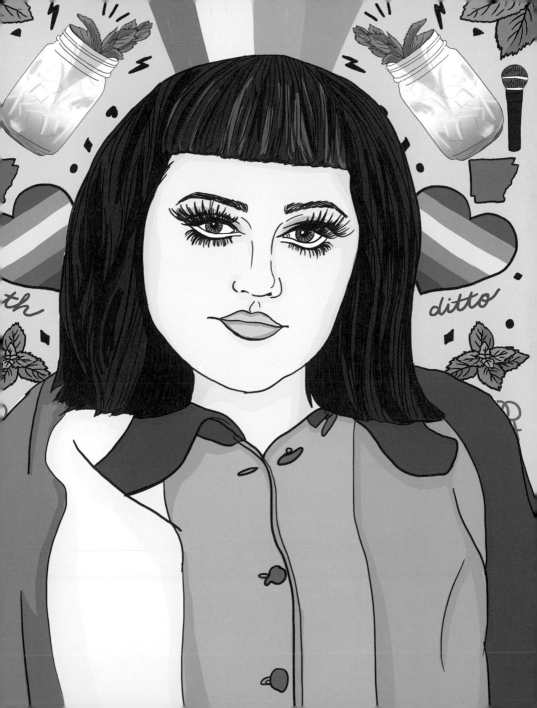

MARLENE DIETRICH

German actor and singer Marlene Dietrich might be the most famous woman ever to don a tuxedo. Her gender-bending style helped redefine acceptable standards of dress, and her charismatic performances made her a household name for over six decades.

Dietrich was born in Berlin and got her start as a stage actor. She lived the bohemian life, attending parties, riding around in a roadster, and hanging around with gay men who were fond of cross-dressing. In order to better fit in with her friends, she had a tailor make her a suit with top hat and tails—even though it was unheard of for women to wear pants at the time. It was a look she took to the big screen. After achieving renown as a film star in Germany, she moved to Hollywood and appeared in *Morocco*, in which she played a cabaret singer. The movie was controversial for portraying a tux-wearing Dietrich giving a smoldering kiss to another woman. Not that she cared; she was known for her many affairs—with both men and women.

Dietrich never gave up her reputation as an androgynous vamp. In her later years, she was a successful cabaret performer and became known for wearing a daringly see-through dress for the first half of her act and, later, changing into a tux and top hat to sing songs normally crooned by men.

Legend has it that, on film sets, she used to suck on lemons to keep her mouth taut onscreen. She frequented a Hollywood bar and ordered a citrusy drink so often that the bartender renamed it the Marlene Dietrich; obviously, she'd order one in a snap.

The Marlene Dietrich

2 shots rye whiskey
½ shot Cointreau
3 dashes Angostura bitters
Garnish: lemon and orange wedges

Combine ingredients in a mixing glass, stir well, and strain over ice into a rocks glass. Garnish with lemon and orange wedges.

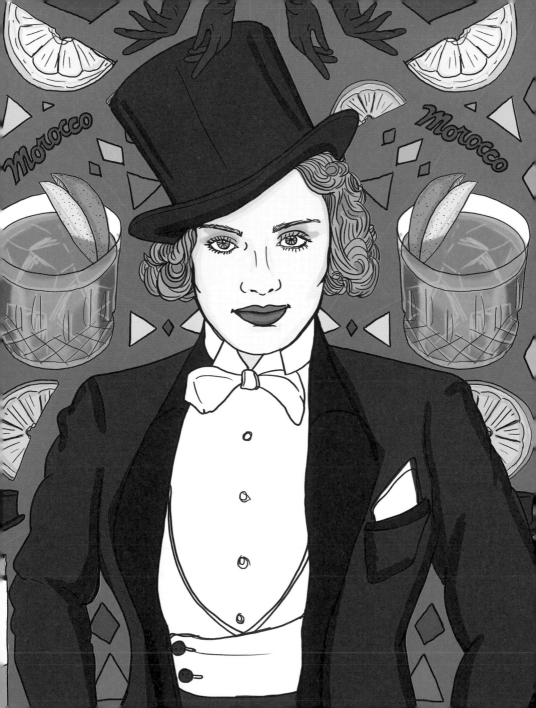

ZAHA HADID

The Zaha Hadid

2 shots gin
1 shot simple syrup (p. 14)
½ shot light cream
 (single, around 18% fat)
½ shot fresh lemon juice
½ shot fresh lime juice
3 dashes lavender water
1 medium egg white
2 shots club soda (soda water)
Garnish: sprig of lavender

Add all ingredients, except club soda, to a cocktail shaker and shake vigorously for as long as you can—at least a minute, but longer is better. Then, add ice to the shaker until it's about three-quarters full and shake for another minute, or ideally until the ice is gone. Your arms should be sore by the end of this. Strain the mixture into a Collins glass and top with club soda. Garnish with a sprig of lavender.

Queen of the Curve—that's what they called Iraqi-British superstar architect Zaha Hadid. Her sweeping, often curvilinear designs broke boundaries and blew minds, and wherever her buildings reside, they never, ever blend in.

Early on, Hadid had a hard time convincing anyone to erect the structures she dreamed up; her former teacher Rem Koolhaas described her as "a planet in her own orbit." While her designs which she rendered as colorful paintings, were gorgeous and unique, they were too ambitious for most developers. Expensive and iconoclastic, they were often deemed unbuildable. Hadid finally got a break when the German furniture company Vitra hired her to design a fire station for their factory in 1991. Her sculptural concrete and glass design became famous in magazines before it was even constructed, which jumpstarted her career, paving the way for contemporary buildings like the London Aquatics Centre for the 2012 Olympics, the Eli and Edythe Broad Art Museum in Michigan, the Guangzhou Opera House in China, and the Al Wakrah Stadium in Qatar, the design for which went viral when people noticed it looked just like female genitalia. Hadid vehemently denied this was intentional, but in a world of phallic architecture, it's a refreshing change.

A woman whose buildings were impossible to build deserves a cocktail that is challenging to make. This drink, based on a Ramos Gin Fizz, requires a lot of determination and supple arm muscles, but if you work hard enough, you'll be rewarded with a frothy cocktail that's beautiful to behold.

86

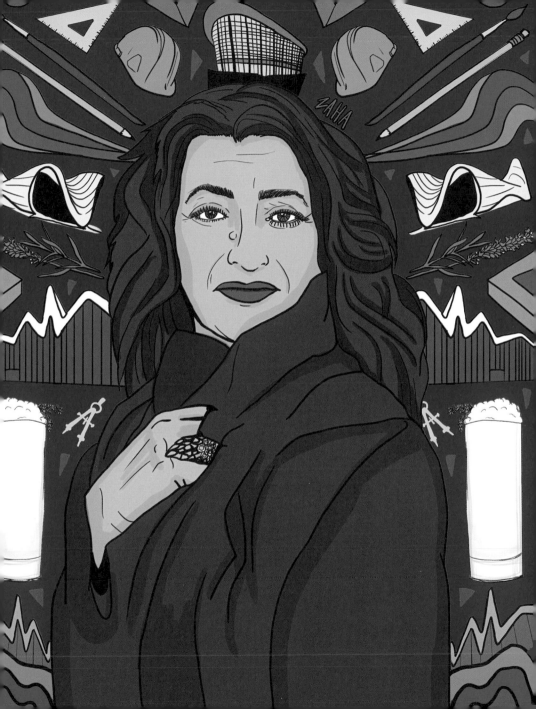

VIVIENNE WESTWOOD

Godmother of punk Vivienne Westwood continued to raise hell into her '80s, decades after mohawks became a fashionable way of claiming nonconformity. In the late '70s, Westwood went from English country girl to punk provocateur, collaborating with her then-boyfriend Malcolm McLaren on his Chelsea, London-based store SEX (later renamed Seditionaries), which sold outrageous clothing she designed: things like skintight trousers, zippered tops, and T-shirts with sexually provocative prints on them. The look, which McLaren used on a band he managed—the Sex Pistols, whose nose-thumbing "God Save the Queen" was arguably the most famous punk anthem—came to define the movement.

In the post-punk era, Westwood moved from the underground realm to high fashion, splitting from McLaren in the process. Her designs were inspired by fashion history, particularly English period clothing. She became a political force, too, campaigning for civil liberties, human rights, and environmental causes. Famously, she appeared on the cover of *Tatler* magazine dressed as British Prime Minister Margaret Thatcher in 1989 (Maggie was not amused). In more recent years, she dedicated a collection to Chelsea Manning, used her runway shows to raise awareness for climate change, and, most shockingly, drove a tank to David Cameron's house to protest against fracking. Despite Westwood's anti-authoritarian tendencies, she was embraced as a cultural icon, and was made a Dame in 2006.

As a rabble-rousing Anglophile, Westwood would likely have enjoyed a spin on the Bramble, a cocktail invented in '80s London. Crème de cassis makes this drink as Ribena-purple as the boldest mohawk, while lemon juice gives it an edge.

The Vivienne Westwood

2 shots gin
1 shot crème de cassis
1 shot fresh lemon juice
Garnish: fresh mint

Add ingredients to a cocktail shaker. Shake, and pour over crushed ice in a rocks glass. Garnish with fresh mint.

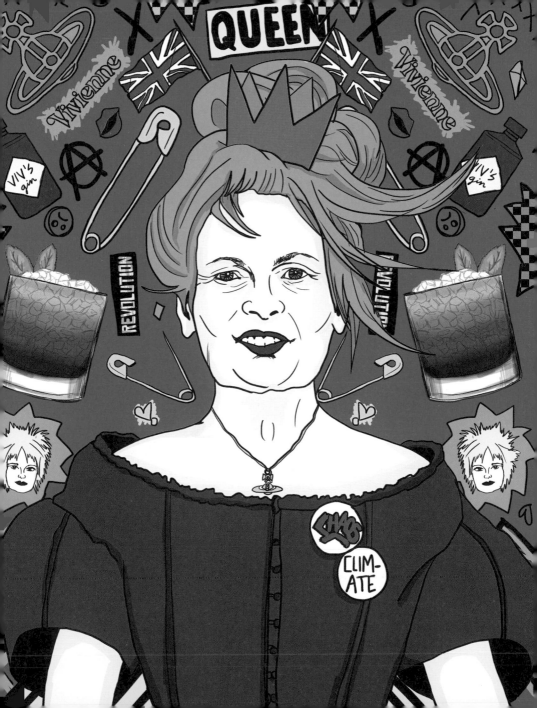

FLO-JO

The Flo-Jo

For the raspberry syrup
½ cup / 100 g sugar
¼ cup / 30g raspberries

**Bring ½ cup / 120 ml water
and sugar to a boil. Take off heat.
Add raspberries and bring to
a simmer for 5 minutes. Strain
to remove the raspberry
chunks (save the raspberries
for something else!).**

For the cocktail
**1 shot raspberry syrup
½ shot blue Curaçao
3 shots San Pellegrino lemonade
1½ shots vodka**

**Fill a highball glass with crushed ice.
Pour in raspberry syrup. Slowly pour
in the blue Curaçao on top, to layer.
In a separate glass, mix together
lemonade and vodka, and slowly pour
into glass over top of the blue Curaçao.
Serve with a straw and a spoon—the
drink looks pretty layered, but you'll
want to stir it up before you drink it.**

A blur of flashy clothes, big hair, and four-inch nails: if you were lucky enough to see her whizz by, that was Flo-Jo. Olympic sprinter Florence Griffith Joyner set records that made her the fastest woman of all time—and, with her audacious fashion sense, looked damn good while she was doing it.

Born in California, Flo-Jo was always quick. As a little kid she visited the Mojave Desert with her dad, where he dared her to chase jackrabbits; she actually caught one. By high school, she was already setting records in track, but it was her performances at the Olympic Games, first in 1984, and then in 1988, that made her an athletic icon. For her races, Flo-Jo wore getups including asymmetrical tracksuits with one leg, lace leggings, and a hooded running uniform, all of which turned her into a media darling. Unlike many runners, who avoided donning any material that wasn't aerodynamic, she accessorized with jewelry and wore her long, wavy locks down so they could fly behind her as she ran. And then there were her nails, which were super long and always painted in a wild array of hues. Stood beside her conservative, Spandex-ed competitors, there was no blending in, but that was okay: Flo-Jo was faster than all of them anyway. When she accepted her three golds and a silver at the 1988 Olympics, she lacquered her nails a patriotic red, white, and blue.

Flo-Jo retired in 1989, and passed away in her sleep from a seizure at age 38. But running—and sports generally—were never the same. After her, it was okay for athletes to be their freakiest, most fashionable selves, whether they were on the street or the podium.

Her drink is a layered cocktail using the American flag's colors—to match her Olympic victory nails.

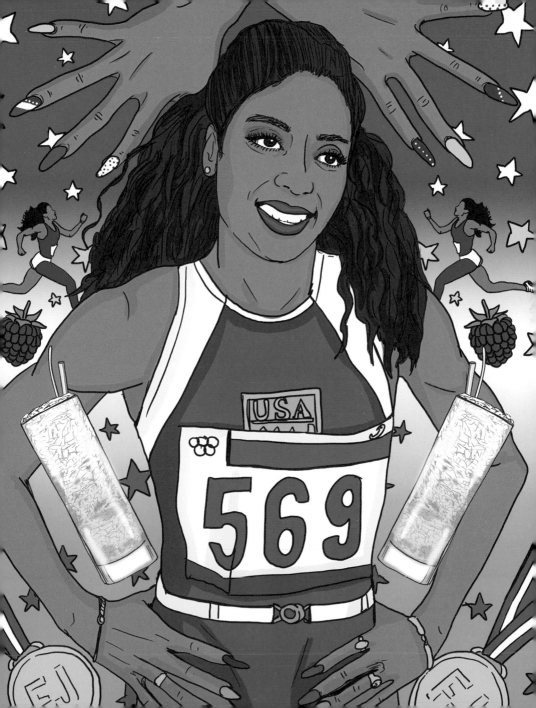

b. 1949

MERYL STREEP

The Meryl Streep

For the cinnamon syrup
½ cup / 100 g white sugar
4 cinnamon sticks

Mix sugar and ½ cup / 120 ml water in a pot. Bring to a boil, add cinnamon sticks, and allow to simmer for 5 minutes. Allow to cool, remove cinnamon sticks, and refrigerate until needed.

For the cocktail
1½ shots bourbon
½ shot fresh lemon juice
½ shot cinnamon syrup
Sparkling dry cider
Garnish: thin slices of apple

Combine bourbon, lemon juice, and syrup in an ice-filled shaker. Strain into an ice-filled Collins glass, and top with cider. Garnish with a few thin slices of apple.

Meryl Streep has the power to assume almost anybody's identity. Considered the best actor of her time, she can seamlessly transform into new people, from Margaret Thatcher to Anna Wintour, without breaking a sweat.

Streep got her start in acting onstage, first appearing in high school plays and eventually, after earning an MFA in drama from Yale, in New York theater productions. She began auditioning for films, which didn't entirely go off without a hitch: when she tried out for a remake of *King Kong*, the director said to his son, in Italian, "Why do you bring me this ugly thing?" Streep replied to him, also in Italian, "I'm sorry I'm not beautiful enough to be in *King Kong*." Though she may not have landed the role of a damsel in distress in that movie, Streep nailed a part in *The Deer Hunter*, which led to starring turns in a string of critical and commercial successes, including the films *Kramer vs. Kramer*, *Sophie's Choice*, *Postcards from the Edge*, *The Devil Wears Prada*, *The Iron Lady*, and more recently, the television show *Big Little Lies*. Over the course of her career, Streep has been nominated for a staggering number of awards—close to 400—including more Oscars than any actor, male or female, ever.

Despite all the accolades, Streep is resolutely normal. She's never the subject of tabloid fodder, and lives a life largely outside the spotlight. Her cocktail is a tribute to her versatility and understatedness. It relies on apples (in cider form), the most adaptable fruit, and enough bourbon to give it a backbone of steel.

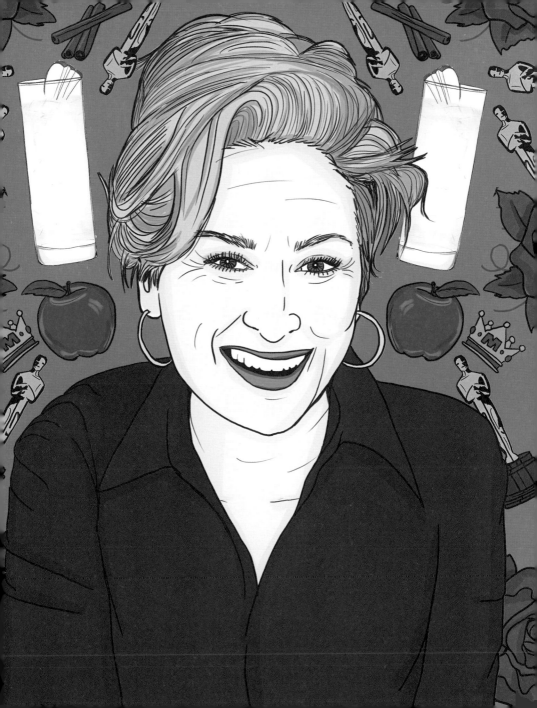

b. 1975

ZADIE SMITH

Some writers take years to make it (and most never do), but Zadie Smith has been a sensation ever since she published her first book, *White Teeth*, at age 24. Her broad, sweeping novels cleverly and deftly examine race, class, cultural identity, and celebrity, and their beautifully-crafted sentences and engrossing plots have made her a giant of contemporary literature.

As a half-Jamaican, half-English woman who grew up in northwest London, Smith has long been both a symbol for and an interpreter of multicultural Britain. *White Teeth* explored that very theme through the tale of three culturally-diverse families whose lives intersect in England's capital. Her subsequent novels considered topics ranging from the nature of beauty to female friendship, with liberal doses of pop culture; *Swing Time*, for example, included a Kylie Minogue-inspired singer.

Smith is also a style inspiration and role model for creative, ambitious women. With her chunky glasses, patterned tops, and turbans, she's made the pages of *Vogue*, while her ability to consistently deliver gorgeous prose, year after year, has made her the envy of writers everywhere. Her cocktail is inspired by tradition, but isn't too beholden to it. A chocolatey spin on a Sazerac, it's served in a teacup—like a proper English cuppa.

The Zadie Smith

1 sugar cube
2 shots bourbon
½ shot crème de cacao
2 dashes Peychaud's bitters
½ shot absinthe
Garnish: lemon peel

Put a sugar cube in a mixing glass with enough water to soften it and crush with a spoon. Add bourbon, crème de cacao, bitters, and ice, and stir until chilled.

Take a teacup and pour in absinthe. Turn the glass until the absinthe has coated it on all sides, and then pour out the excess. Strain the bourbon mixture into the teacup and garnish with a thick piece of lemon peel.

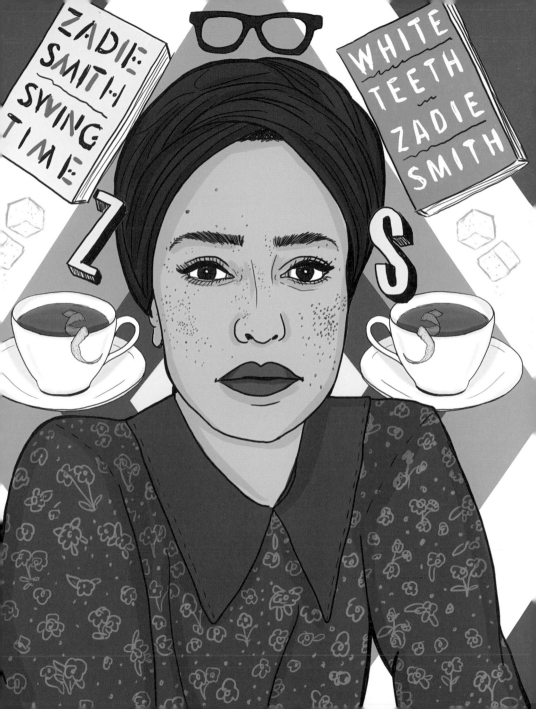

1908–1986

SIMONE DE BEAUVOIR

The Simone de Beauvoir

For the apricot shrub
2 apricots
Sugar
Cider vinegar

Cut up apricots into small pieces and roll each piece in sugar to coat on all sides. Place in an airtight container in the fridge for a day or two. Strain out the liquid and pour into a container. Add an equal amount of cider vinegar, and place in the fridge to chill for 2 days.

For the cocktail
1½ shots bourbon
1 shot apricot shrub
Apricot slices
Club soda (soda water)

Pour bourbon and apricot shrub into a Collins glass with ice. Add thin slices of apricot. Top with club soda.

Simone de Beauvoir was one of the most famous existentialist philosophers of the early 20th century, and she dedicated much of her writing to the existence of a so-called "second sex"—women.

Beauvoir was raised in an upper-middle-class family in Paris. As a child she was very religious but, after a crisis of faith as a teenager, she became an atheist. Her marriage prospects were limited after World War I demolished her family's fortune, but Beauvoir saw this as an opportunity; she could make a life of her own. Devoting herself to academia, she achieved the equivalent of a master's degree by 1928, when she was 20 years old. Soon after, she began a relationship with Jean-Paul Sartre, and the two became the reigning couple of French philosophy. Beauvoir's lifelong romance with Sartre was unconventional: they never wed, and both pursued other lovers (and sometimes shared them).

A prodigious writer, Beauvoir penned many novels, essays, and papers. She's most famous for her philosophical text *The Second Sex*, in which she famously wrote, "One is not born, but becomes, a woman"—meaning that women's secondary status is imposed on them by a patriarchal society. Her work laid the foundation for feminism's second wave.

Beauvoir used to meet in Parisian cafés with other eminent thinkers to debate the nature of existence over apricot cocktails, and so her drink is apricot-based— discourse optional.

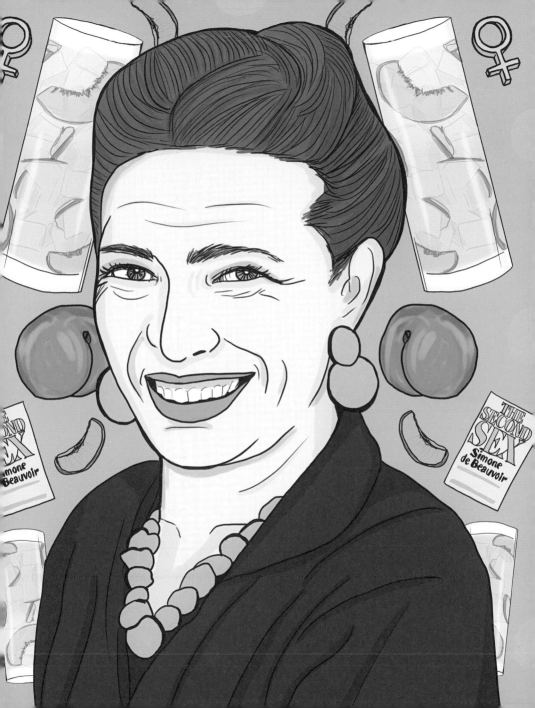

MARINA ABRAMOVIĆ

No confrontation is too awkward or extreme for Yugoslavian-born performance artist Marina Abramović. For decades, she has been using her body to provoke audiences and explore the boundaries of human experience, earning her the nickname "the grandmother of performance art."

Right from Abramović's first performance in Edinburgh in 1973, she flirted with ritual and pain. In her work titled *Rhythm 10*, she played the so-called "knife game," splaying her hand and stabbing a knife in the gaps between her fingers, hoping to maintain enough focus not to cut herself. By 1974, she began to interact more with her audience and, in a controversial piece called *Rhythm 0*, allowed visitors to do whatever they wanted to her with a selection of 72 items. By the end of it, the audience had stripped Abramović of her clothing and left her with cuts on her skin. One of them even put a gun to her head. "What I learned was that … if you leave it up to the audience, they can kill you," she said.

Today, she is best-known for *The Artist is Present*, the blockbuster performance she staged for three months in 2010 at MoMA in New York. People lined up for hours to sit in a chair opposite Abramović and stare silently into her eyes for however long they wished. There were 1,545 participants in total, including celebrities such as Björk and Isabella Rossellini. Some found the experience so emotional that they were moved to tears.

Abramović's cocktail uses ingredients from the earth, like beets (beetroot) and ginger, which give it a rich, primal flavor. The beet juice makes it a deep, visceral red.

The Marina Abramović

2 small (½-inch) chunks fresh ginger
2 shots Scotch
1 shot beet (beetroot) juice
1 shot fresh lemon juice
1 shot honey syrup
 (half hot water, half honey)
Garnish: candied ginger
 on a cocktail pick

Muddle ginger in a shaker, add all other ingredients, and shake with ice. Serve in a coupe glass, and garnish with candied ginger on a cocktail pick.

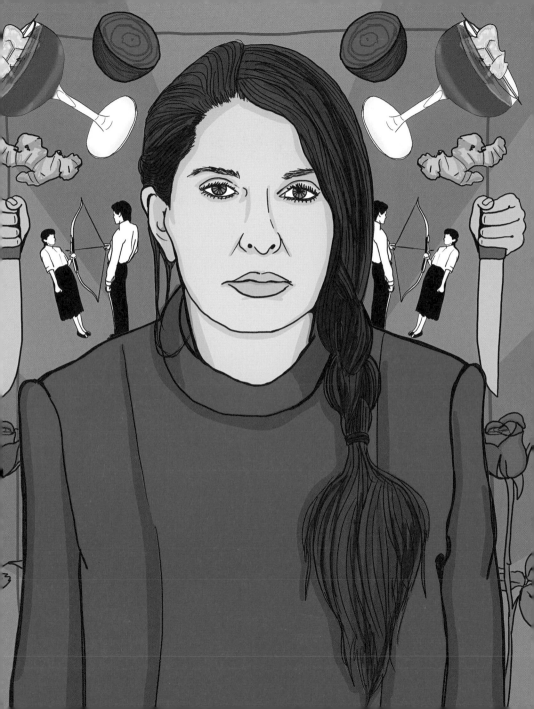

MINDY KALING

The Mindy Kaling

2 scoops vanilla ice cream
2 shots dark rum
Ginger beer
Garnish: lime round

Add vanilla ice cream to
a Collins glass. Pour in dark
rum and top with ginger beer.
Garnish with a lime round.

Mindy Kaling is everyone's aspirational BFF. The characters she writes and plays are like an embodiment of our collective inner monologue, making her relatable—and a little disarming.

Kaling grew up in Massachusetts with her architect dad and doctor mom, but she bucked the family trend toward professional degrees by studying to be a playwright. After graduating she hustled hard, working as a production assistant in television, and doing stand-up comedy in nightclubs. Eventually, one of her spec scripts landed her a gig on a show—*The Office*. Kaling's goofy character, Kelly Kapoor, garnered accolades from TV audiences, while she was also making a name for herself behind the scenes as the show's most prolific writer. Her success on *The Office* eventually led to her very own program. *The Mindy Project*, a half-hour romantic comedy that lasted five seasons, turned Kaling into a pioneer: she was the first South Asian woman to play the lead on (as well as produce and write) a major network show. And in 2020, she created a series for Netflix based on her childhood titled *Never Have I Ever*, which has been praised for its stereotype-busting representation of South Asian characters.

Never one to bow to convention, Kaling decided to go her own way and have two children (born in 2017 and 2020) as a single parent, keeping the biological dad's identity a secret—a rarity in Hollywood.

Kaling claims her favorite drink is a Dark 'n' Stormy, but this is the girls' night, put-your-sweatpants-on, we're-staying-in version: a Dark 'n' Stormy float.

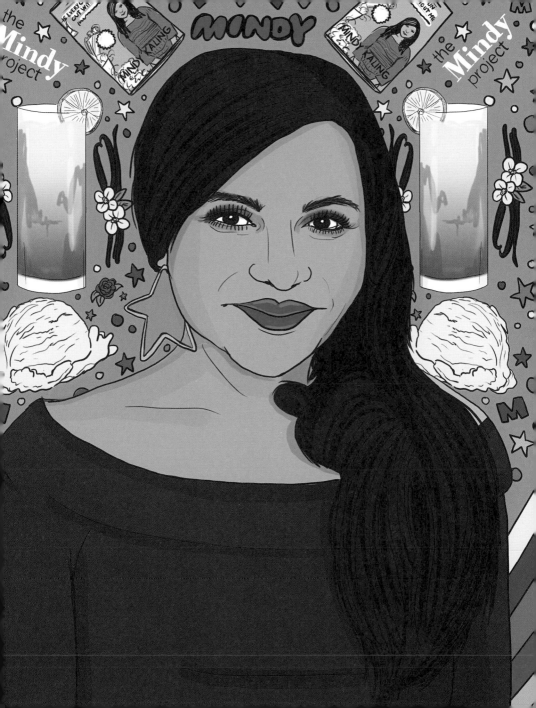

EDITH PIAF

The Edith Piaf

1½ shots Hendrick's (a rose-
 and cucumber-infused gin)
½ shot simple syrup (p. 14)
¼ shot grenadine
¼ shot fresh lemon juice
¼ shot fresh grapefruit juice
3 dashes rose water
Garnish: rose petal

**Combine all ingredients in
a shaker, shake with ice,
and strain into a coupe glass.
Garnish with a rose petal.**

Few people embody the spirit of their country like Edith Piaf.
A cabaret singer whose songs brim over with love and loss,
she's widely considered to be France's national chanteuse.

The sadness in Piaf's torch songs stems from a difficult
childhood. Abandoned at birth by her mother, she grew up
in a brothel. In her early teens, she began to perform on the
street with her father. Her beautiful and quirky voice led,
eventually, to her being discovered by a cabaret nightclub
owner, who brought her to the stage. Though she was a tiny
woman (only 4'8"), Piaf belted out tunes with all of her
might, dressed in a classy black sheath dress that became
her trademark, leading to the nickname "little black sparrow."
She began to put out albums, and soon became a major
star within France, persevering even through the German
occupation of the country during World War II. The romantic
lyrics of one of her biggest songs, "La Vie en Rose,"
encouraged her countrymates to embrace life and love
again after the war.

Piaf's life was unusually tragic. She was involved in three
major car crashes, leaving her in constant pain which
she self-medicated with drugs and alcohol. Nonetheless,
she sang through it all. Her final anthem, "Non, Je Ne
Regrette Rien," demonstrated her feisty resolve in the face
of hardship—she truly didn't regret any of it.

Piaf's drink, flavored with rose syrup and rose- and cucumber
infused gin, will help anyone to live *la vie en rose*.

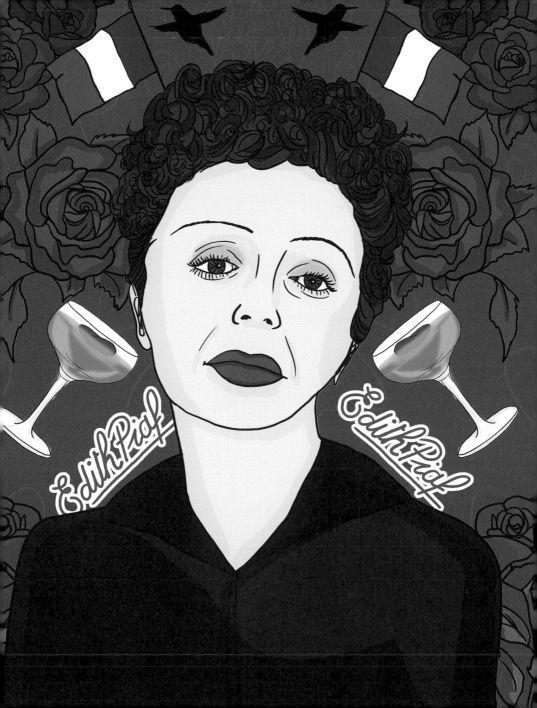

b. 1970

NAOMI KLEIN

Brazen anti-capitalist agitator and environmental activist Naomi Klein is one of the most influential progressive figures alive. Her ideas about globalization, consumerism, free-market economics, and climate change have revolutionized the way we view the world.

Born in Montreal, Klein was raised by draft-dodging American hippie parents. As a teen, she rebelled against her left-wing upbringing by becoming a mallrat who loved shopping and designer clothing. That all changed when she began university and was shocked into reality by the 1989 École Polytechnique massacre, a sexist attack where a man murdered 14 female engineering students. It was a turning point that awakened her feminist instincts and inflamed her politics.

Klein rose to fame after she published the blockbuster anti-branding bible *No Logo* in 2000, a book that channeled the anti-globalist zeitgeist and transcended sociological theory to become a pop culture classic. *The Shock Doctrine*, released in 2007, was heralded as a hugely-important tome on economics and "disaster capitalism," while 2017's *No Is Not Enough* examined the political shock of Donald Trump's presidency. In 2014, her climate change manifesto, *This Changes Everything*, called for an ecological revolution to save our planet—a topic she revisited in her 2019 essay collection, *On Fire: The (Burning) Case for a Green New Deal*.

Klein's cocktail is an anti-capitalist elixir made from ingredients from small producers. One sip will make you want to fight the man.

The Naomi Klein

4–5 organic blackberries
3 basil leaves
1½ shots locally-sourced vodka
Kombucha
Garnish: basil

Muddle blackberries and basil leaves in the bottom of a Collins glass. Pour in vodka, add ice cubes, and top with kombucha. Garnish with a sprig of basil.

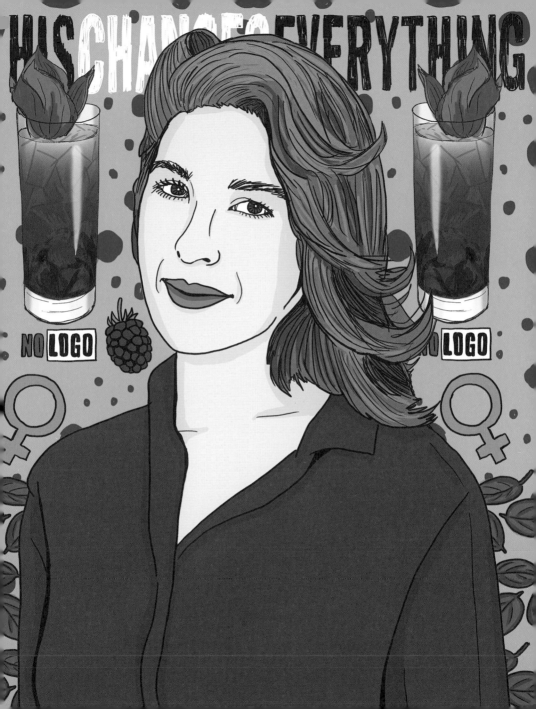

GRACE CODDINGTON

Many of the most iconic images in fashion have been masterminded by Grace Coddington. With her wild orange hair, often shapeless black clothing, and comfortable shoes, she became an unlikely—but beloved—heroine in an industry focused on looks.

Coddington grew up in a remote corner of Wales, where her monthly subscription to *Vogue* was her only connection to the larger world. That all changed when, at age 17, she won a modeling competition with the magazine and embarked on a career in London. Her time in front of the camera was cut tragically short after she was involved in a car accident that damaged her face, but she didn't give up, finding another way to use her aesthetic talents—as an editor and stylist at *Vogue*.

In this new role, Coddington dreamed up emotional and compelling fashion stories that imbued clothing with meaning. However, she largely remained behind the scenes until she appeared in *The September Issue*, a 2009 documentary film that chronicled the making of one issue of the mag. Her creative vision, impassioned fights with notorious editor Anna Wintour, and personal charm made audiences fall in love with her. Almost overnight, Coddington became a star. Fashion editorials featuring models styled with frizzy tangerine hairdos appeared in magazines, and her memoir, *Grace*, became a bestseller.

Coddington's cocktail could only be one color: orange. An Aperol Spritz, it's fizzy, not too sweet, and very photogenic.

The Grace Coddington

3 shots prosecco
2 shots Aperol
1 shot club soda (soda water)
Garnish: orange slice

Into a wine glass full of ice, pour (in this order) the prosecco, Aperol, and club soda. Garnish with a slice of orange.

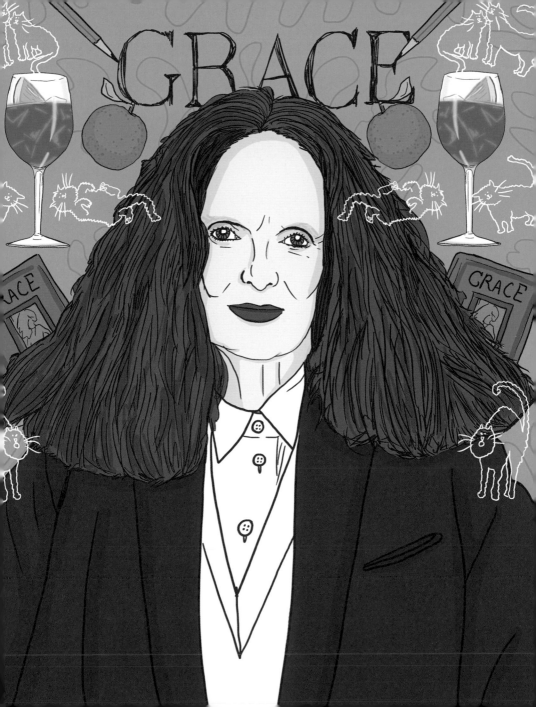

DOLLY PARTON

A relentlessly good-natured icon who redefined country music with her trembling soprano voice and voluptuous blonde tenacity, Dolly Parton is arguably the most famous country star alive today. She grew up in poverty in the Tennessee mountains, singing songs about Jesus at the local church. Owing to her sweet voice and obvious talent, she got a record deal by her early teens. Eventually she wound up co-starring on a musical variety TV show with country singer Porter Wagoner. When Parton broke off on her own, her song about the split, "I Will Always Love You," became a heart-wrenching hit that's been covered by many—most memorably by Whitney Houston. But the song that really defined Parton's sound was "Jolene," an emotionally vulnerable ballad that implored another woman not to take away her man. Her long-running success in country music was interrupted only by occasional appearances in female-fronted movies like *The Best Little Whorehouse in Texas*, *9 to 5*, and *Steel Magnolias*. Her likeable public image was enhanced by her work as a philanthropist; she donates millions to charity, and in 2020 made headlines for helping to partially fund the Moderna Covid vaccine.

Nobody looks quite like Parton. But while she embraces extremes in her appearance, she plays up the earnestness in her personality. As she told *The Sun* in 2014, "My boobs are fake, my hair's fake, but what is real is my voice and my heart." She's also rumored to have tattoos all over her torso, including full sleeves on her arms, which she hides with carefully-placed clothing. The intrigue just makes everyone love her more.

In the past, Parton has declared her adoration for both red wine and tequila, so this Sangria con Tequila is right up her alley.

The Dolly Parton
Serves 6–8

1 bottle red wine
½ cup / 120 ml silver tequila
2 lemons, cut into thin slices
2 limes, cut into thin slices
1 orange, cut into thin slices
Several mint leaves, torn
⅔ cup / 180 ml agave syrup
¼ cup / 60 ml fresh lime juice
2 cups / 480 ml club soda (soda water)
Garnish: handful of mint

Combine red wine, tequila, fruit, mint, agave, and lime juice in a large pitcher and stir. Top with club soda. Refrigerate for at least an hour before serving. To serve, scoop fruit from the pitcher into large Mason jars, add ice, and pour in the Sangria. Garnish with a handful of mint.

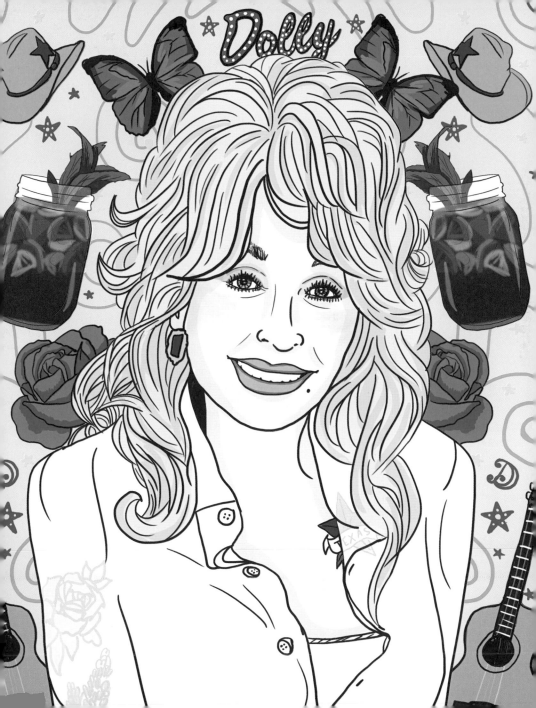

ELLA FITZGERALD

There's no jazz singer more cherished—or versatile—than Ella Fitzgerald. The "First Lady of Song" used her crisp, precise voice to redefine a jaw-dropping range of American classics, establishing herself as the premier vocal stylist of her era.

Fitzgerald's path to stardom was a classic rags-to-riches story. She was orphaned as a teen, and difficulties at home and school eventually led to her living on the street. But the spontaneous decision to participate in a talent competition at New York's legendary Apollo Theater was her salvation: a virtuoso performance won her first place and, soon after, she established a career as a singer.

In 1938, Fitzgerald released what would become her first number one hit: "A-Tisket, A-Tasket," a reworking of the well-known nursery rhyme. After this, rewriting and improvising popular songs from a variety of genres became one of her trademarks. Between 1956 and 1964, she recorded a series of eight albums that ambitiously reinterpreted the Great American Songbook, including tunes like "It Don't Mean a Thing (If It Ain't Got That Swing)." She also excelled at scatting, using her voice as an instrument. Fitzgerald became the first African American woman to win a Grammy in 1958, and she racked up another 13 through her long and varied tenure.

Fitzgerald's drink is bright yellow, an homage to the basket she mourns losing in "A-Tisket, A-Tasket." It's a Rosemary Lemon Drop, a pleasant mix of sweet and tart.

The Ella Fitzgerald

For the rosemary syrup
½ cup / 100 g sugar
4 rosemary sprigs

Bring ½ cup / 120 ml water and sugar to a boil and then turn down to a low heat. Add sprigs of rosemary, simmer for 4 minutes, and allow to cool. Remove rosemary sprigs and refrigerate.

For the cocktail
1½ shots vodka
¾ shot fresh lemon juice
¼ shot rosemary syrup
Garnish: rosemary sprig

Add ingredients to a shaker full of ice. Shake vigorously and strain into a coupe glass. Garnish with a rosemary sprig.

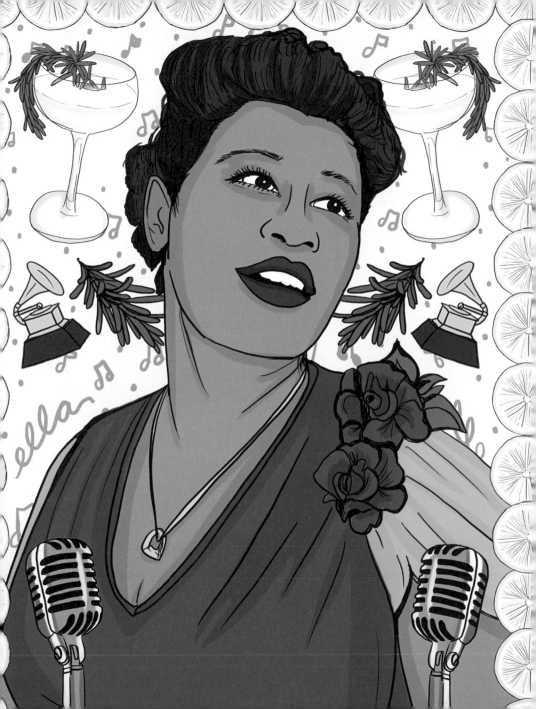

NIGELLA LAWSON

The Nigella Lawson
Serves 4

2 eggs
⅛ cup / 25 g sugar
1 cup / 240 ml whole milk
½ cup / 120 ml whipping
 (double) cream
3 shots bourbon
2 shots amaretto
1 tsp cinnamon
Garnish: cinnamon stick

Separate eggs and, in a large bowl,
beat yolks until they turn a pale
yellow. Add sugar and beat until
dissolved. Add milk, cream,
bourbon, amaretto, and cinnamon,
stirring gently until combined.
In a separate bowl, beat egg whites
until stiff. Stir into milk mixture
and chill. Serve in a Mason jar and
garnish with a cinnamon stick.

Decadence, thy name is Nigella Lawson. The self-styled
British domestic goddess uses ample quantities of flour,
butter, and sugar to make a very good point: eating should
be about pleasure.

Her path to foodie fame began after attending a disastrous
dinner party, where she witnessed the host weeping over
a crème caramel that wouldn't set. Lawson—a journalist
who admitted that she was "an eater," and not a chef—came
to the rescue. Her first cookbook, *How to Eat*, focused on
simplicity in the kitchen, while her second, *How to Be a
Domestic Goddess*, was all about indulgence and baking.
From there, she began hosting TV shows like *Nigella Eats* and
Nigella Feasts, and her warm, flirtatious manner helped her
win people over to the idea that cooking was fun and even
sensual. She proved she could influence culinary trends on
a large scale, too: when she included Riesling in a chicken
recipe, she single-handedly caused sales of the wine to jump
by 30 percent.

Lawson is best known for delicious, satisfying recipes that
include lots of rich meat, carbs, dairy, and sweets. She's
a firm believer that we should enjoy what we eat, and that
consuming a brownie isn't a moral failure—it's a sure way
to appreciate being alive.

Lawson's cocktail is as indulgent as they come: Eggnog.
It incorporates rich cream and bourbon; what could
be better than that?

1883–1971

COCO CHANEL

No name is more synonymous with fashion than Coco Chanel. The founder of the House of Chanel made an indelible mark on the world of style by transforming once-fussy women's clothing into something chic, streamlined, and liberating.

Gabrielle Bonheur Chanel was born far from fashion's epicenter, in a poorhouse in rural France. When her mother died, her father left her at an orphanage run by nuns. Her upbringing was strict and austere, but at least the nuns taught her how to sew. When she was 18 she parlayed that skill into a job as a seamstress, while also singing in cabarets at night. Among the wealthy men who frequented the cabaret, she met textile heir Étienne Balsan, who helped fund her first shop in Paris. Her success as a couturier spanned decades; she worked until her death at age 87. And while today her legacy is darkened by her controversial involvement with Nazis during World War II, her lasting influence on fashion is undeniable.

Chanel's designs, which were modeled after men's country clothing, were sporty and practical; they lacked a corset, meaning that women were able to move freely while wearing them. Her boyish aesthetic became known as the "garçonne look," and it defined the rebellious attitude of flapper-era fashion. Chanel's other innovations included the "little black dress," a practical evening garment that could be worn by women of all classes, and Chanel No. 5, a scent that combined aromas worn by both courtesans and society women. It would become the most popular fragrance of all time.

Chanel once said, "I only drink champagne on two occasions: when I am in love and when I am not." Her cocktail is a classic champagne cocktail, with a little twist: cherry bitters, which adds a fruity tang.

The Coco Chanel

1 sugar cube
Cherry bitters
Champagne
Garnish: fresh cherry

Place a sugar cube in a spoon and liberally douse it with cherry bitters. Put it in the bottom of a champagne flute and top with champagne. Garnish with a fresh cherry.

114

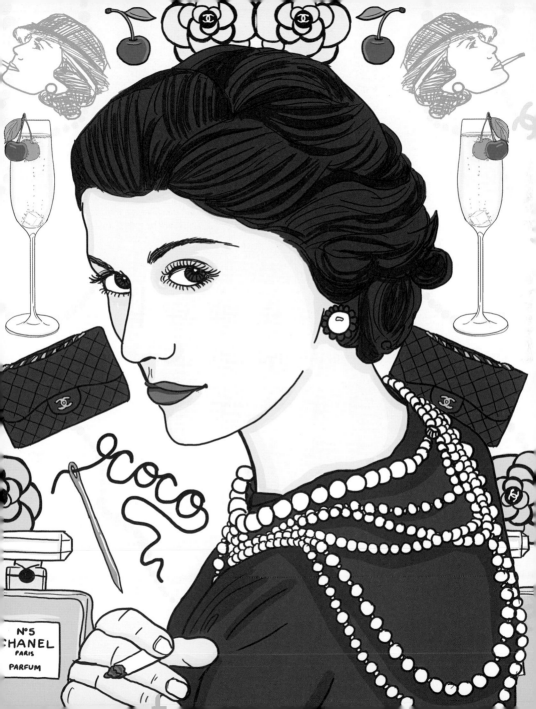

b. 1933

YOKO ONO

The Yoko Ono

1 shot Gekkeikan plum wine
1 shot Cointreau
1 shot fresh lemon juice
2 shots La Croix or club soda
 (soda water)
Garnish: tiny plum

Pour plum wine, Cointreau, and lemon juice into a shaker with ice and shake until mixed. Pour over ice in a rocks glass, top with club soda, and garnish with a tiny plum (or a Bing cherry, if you can't find a small plum).

An avant-garde artist, peace activist, and musician, Yoko Ono has provoked controversy with both her life and her work ever since she left postwar Japan and made a name for herself in Manhattan's underground art scene. Whether she wanted fame or not, she got it after Beatle John Lennon introduced himself to her at a gallery show she was staging in London in 1966. The two became lovers and collaborators; memorably, they spent a solid week in bed in Amsterdam and Montreal hotels in a Vietnam War protest and art installation they called the *Bed-In for Peace*. Because Ono became the focus of Lennon's unwavering attention, she was often characterized in a sexist manner as an evil woman who "ruined the Beatles," and the mainstream press had little regard for her work. But the criticism didn't sway her, and she has continued to produce art, music, and messages of peace up to today.

In recent years, Ono has been recognized as a brilliant pioneer in conceptual and performance art, and in 2018 also received a long-overdue writing credit for her contributions to the Beatles' song "Imagine." In one of the most endearing tributes to her work, *The Simpsons* portrayed her in Moe's Tavern, ordering a very experimental drink consisting of a "single plum, floating in perfume, served in a man's hat." Ono, a woman with a sense of humor, later displayed an art piece that depicted exactly that at a show she curated in Reykjavik, Iceland. Something tells us she would appreciate this drink, which doesn't have to be served in a man's hat—unless you're feeling particularly daring.

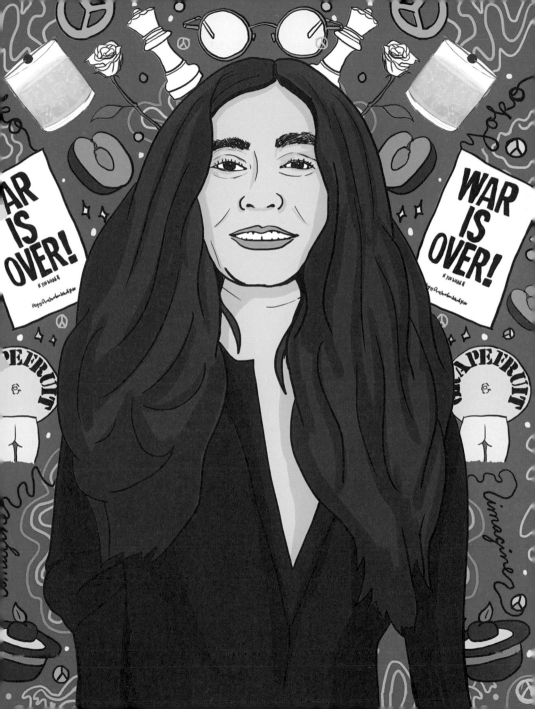

b. 1946

CHER

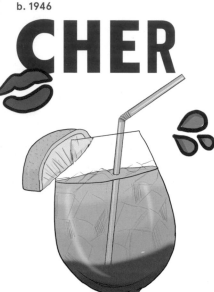

The Cher

2 shots aged rum
½ shot Cointreau
1 shot fresh lime juice
1 shot orgeat syrup
Garnish: lime wedge

Combine ingredients in a shaker with 1 cup / 240 g crushed ice, shake, and pour into a Poco Grande glass. Garnish with a lime wedge and a straw.

Over the past 50 years, pop culture has gone through seismic shifts: hippie folk music was overtaken by disco and then hip hop, MTV killed radio, and the internet made television less relevant. But through it all, one thing has remained constant: Cher.

Born in California to an Armenian dad and a part-white, part-Cherokee mother, Cher has always done things her way. She dropped out of school at age 16 and moved to LA on her own to pursue stardom, dancing in clubs on the Sunset Strip and networking with Tinseltown movers and shakers. That led her to meet Sonny Bono, who became her husband and collaborator; "I Got You Babe," recorded by the two in 1965, was a smash hit (and remains a pervasive earworm to this day). After a bitter split with Bono, Cher became a bona fide rockstar ("Gypsys, Tramps, and Thieves," "If I Could Turn Back Time") and movie star (*Moonstruck, Mermaids*). Never one to blend in, she's made outlandish fashion choices that have made her a style icon: she scandalized audiences by revealing her bellybutton on television in 1975, wore a revealing black bodysuit that got her music video banned from MTV in 1989, and resolutely refuses to "dress her age." And in 2018, she drew rapturous praise from fans for appearing for seven fabulous minutes in *Mamma Mia 2*.

Cher's most notable skill is her ongoing ability to reinvent herself. The Goddess of Pop knows how to stay relevant, and on top of her music and movie success, she can claim another title: Twitter Queen. Her emoji-laden tweets and passionate rants are the stuff of legend, endearing her to a new generation of fans. What better drink for Cher than the emoji cocktail (read: a Mai Tai)? 🍹💙🍹

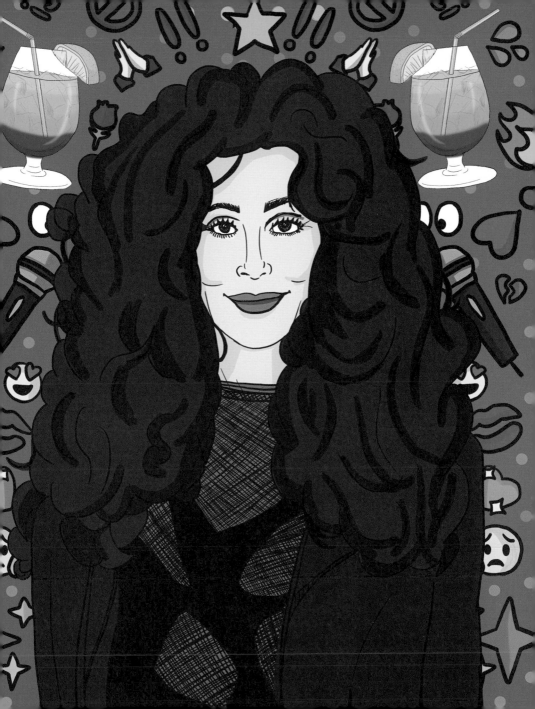

CARMEN MIRANDA

The Carmen Miranda

2 shots cachaça
3 shots coconut milk
1 shot sweetened condensed milk
2 tsp sugar
Garnish: selection of fruits
on a cocktail pick

Add all ingredients to a blender with 1 cup / 240 g ice and blend for 1 to 2 minutes, until smooth. Pour into a Hurricane glass and garnish with a selection of fruits (banana, green and red grapes, pineapple, strawberry) on a cocktail pick.

Chanteuse Carmen Miranda's talents extended far beyond her fully-loaded fruit hat. When she was 21, Miranda—then a milliner—recorded a samba crowd-pleaser that made her a star in her homeland of Brazil. That triumph paved her way to the big screen, where she featured in movies that celebrated Brazilian music and carnival culture. Her look, including the fruity get-up she's famous for today, was an adaptation of "Baiana" fashion worn by impoverished Afro Brazilians in the northeast of the country. By 1940, when she was 31, she was a massive crossover success in the US, which complicated her image at home. Her smash hit film *The Gang All Here* included a number called "The Lady in the Tutti-Frutti Hat," which caused a scandal for the sexual innuendo of scenes featuring scantily-clad dancing girls carrying giant bananas. She was also accused of flattening Latin American society into one homogenous image. Nevertheless, she single handedly popularized South American culture in Hollywood and, today, she's considered a forerunner of the highly-influential Tropicália movement, which has shaped musicians like Beck and David Byrne.

As possibly the most famous Brazilian of all time, Miranda wouldn't settle for anything less than a drink made with cachaça, the iconic sugarcane alcohol produced there. This drink is a traditional Brazilian Batida, a kind of coconut milkshake infused with booze.

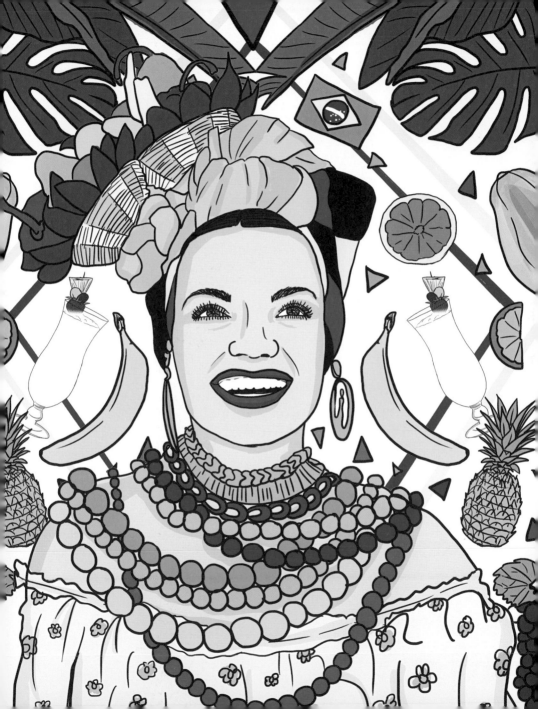

PATTI SMITH

The Patti Smith

1 shot Pernod
5 shots water

Fill a Collins glass with ice cubes, pour in Pernod and water, stir, and serve.

On the cover of her debut album, *Horses*, Patti Smith poses rakishly in a half-untucked white shirt and jeans, with a jacket slung over her shoulder. Her gaze is bold, but somehow vulnerable—a perfect, indelible image of the woman who gave punk its soul. Smith's path to becoming the genre's Poet Laureate began in New York, where she moved at age 23. Soon after she arrived she met the photographer Robert Mapplethorpe, who became her lover and creative inspiration (she later referred to him as "the artist of my life"; he also took the photo for *Horses*). Smith and Mapplethorpe lived in the dilapidated, bohemian Chelsea Hotel and frequented countercultural hangouts like Max's Kansas City, and Smith became involved with the fledgling punk scene, playing music and performing spoken word.

Eventually she recorded *Horses* in 1975, which fused poetry with punk and made her an icon, and later collaborated with Bruce Springsteen on the song "Because the Night," which was her biggest hit. After a pause during the '80s to raise children, Smith continued to release albums and, in 2007, was inducted into the Rock and Roll Hall of Fame. More recently, she has become revered for her other big talent, writing: her book *Just Kids*, about her relationship with Mapplethorpe, won the 2010 US National Book Award for nonfiction and her follow-ups (*M Train, Year of the Monkey*) have been warmly received. Into her 70s she remains a fashion luminary, and one who embraces aging, too: these days, she rocks tousled grey hair with her mannish suits.

Smith adores the French poet Rimbaud and, in his honor, likes to drink Pernod, a French anise-flavored liqueur, a favorite of older French men who frequent cafés. Mixed with water, the green alcohol turns a mysterious, cloudy yellow.

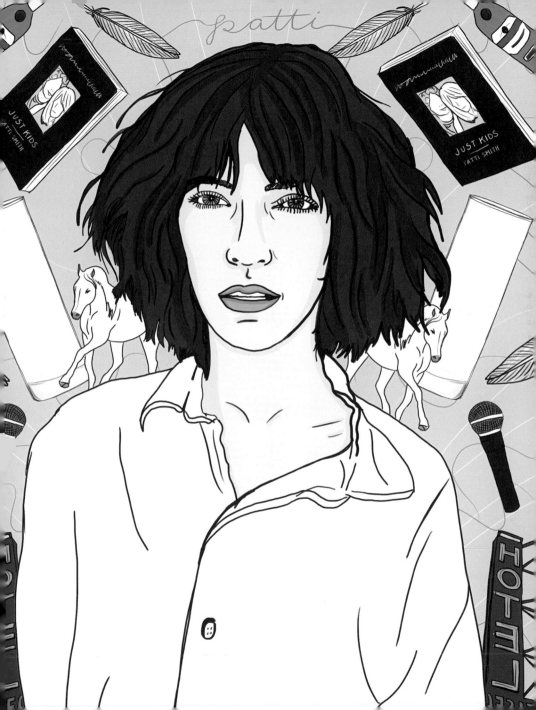

1908–1989

BETTE DAVIS

No actor has relished being a bitch more than silver screen legend Bette Davis. Known for her expressive eyes, scathing wit, and skill at playing challenging characters, she won two Oscars and was nominated for another eight, and always refused to let anybody push her around.

In the beginning, Davis seemed like an unlikely fit for Hollywood stardom. When she got off a train from the East Coast to attend her first screen test in 1930, the studio rep who was meant to greet her at the station left because he didn't see anyone there who "looked like an actress." Davis wasn't a classic beauty, but she had enough talent and attitude for that not to matter. She signed on to roles that others didn't want—women who were bad-tempered, promiscuous, and physically unappealing—and her ability to make them real and believable earned her critical acclaim. She was so concerned with her reputation that, when Warner Brothers began casting her in roles she viewed as beneath her, she took them to court.

Davis had a career-long rivalry with Joan Crawford, and was unsparing in her criticism ("I wouldn't piss on her if she was on fire," she once said). Their relationship was explored in the 2017 TV series *Feud*, which centered on the filming of *Whatever Happened to Baby Jane?*, Davis' 1962 comeback for which she received an Oscar nomination at age 54.

Since Davis was a prodigious smoker and fan of Scotch whisky, her cocktail contains both smoke and Scotch. The fig sweetens the Scotch's richness, while the singed thyme gives the drink an herbal attitude.

The Bette Davis

For the fig puree
5 large black Mission figs, stemmed and halved
1 tsp fresh lemon juice
1 tsp sugar

Combine all ingredients in a food processor with 1 tbsp water and puree until smooth.

For the cocktail
2 shots Scotch
1 shot fig puree
¾ shot fresh lemon juice
½ shot simple syrup (p. 14)
2 dashes citrus bitters
Garnish: thyme sprig

Add all ingredients to a shaker full of ice. Shake and strain into a rocks glass with ice, and place a thyme sprig in the glass. Light a long-stemmed match (don't use a short one or you might get burned) and carefully singe the thyme before garnishing.

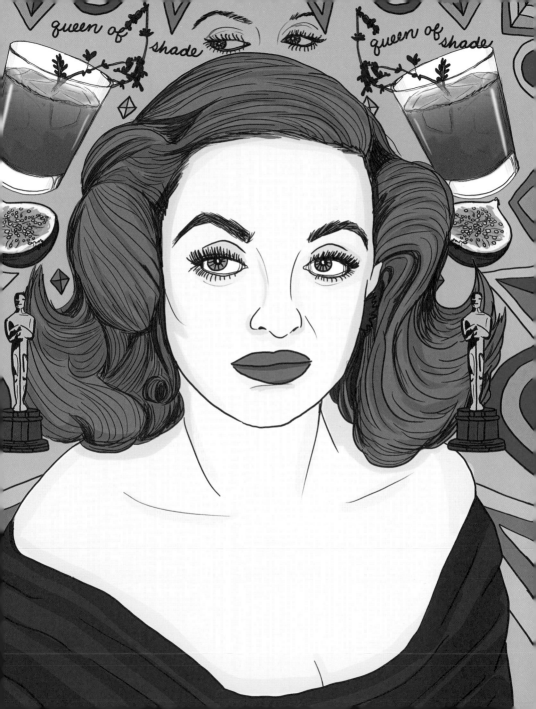

b. 1975

M.I.A.

The M.I.A.

2 shots mezcal
1 shot fresh lemon juice
1 shot simple syrup (p. 14)
1 shot mango juice
1 shot egg white
Garnish: chili salt

Combine ingredients in a shaker, shake with ice, and pour into a rocks glass over ice. Sprinkle the top with chili salt.

For multi-talented creator M.I.A., music, art, and fashion are borderless. The London-born daughter of a Tamil revolutionary, M.I.A. (aka Maya Arulpragasam, her given name) spent much of her childhood in Sri Lanka, living in poverty while her father was involved in activism. Eventually, the family (minus dad) moved back to London as refugees. While M.I.A. got along just fine in Britain, she never forgot her experiences growing up. When she went to college to study film, she was frustrated by her classmates' naive perspectives. "Social reality didn't really exist there; it just stopped at theory," she said.

When M.I.A. began writing and producing music, social reality was exactly what she brought to it. Inspired by global genres like dancehall, jungle, and Brazilian baile funk, as well as hip hop and electroclash, she created edgy, danceable beats with a political edge. One of her first hits, "Bucky Done Gun," was a favela-funk tune that referenced soldiers pounding at the door, while her biggest song ever, "Paper Planes," tells the story of a passport counterfeiter. Her more recent songs are equally political. Visual culture and clothing play an important part in M.I.A.'s image, too. She draws from international street style and urban aesthetics to create art for her albums and live shows, plus is known for a colorful, un-pin-down-able fashion eclecticism that is as unique, and varied, as her sound.

M.I.A.'s cocktail borrows from more than one culture: the ripe flavors of mango would be at home in Sri Lanka, while mezcal is a traditional alcohol from the fields of Mexico. They come together in this version of a sour, a cocktail that may have been invented in the US, or maybe Britain; nobody really knows.

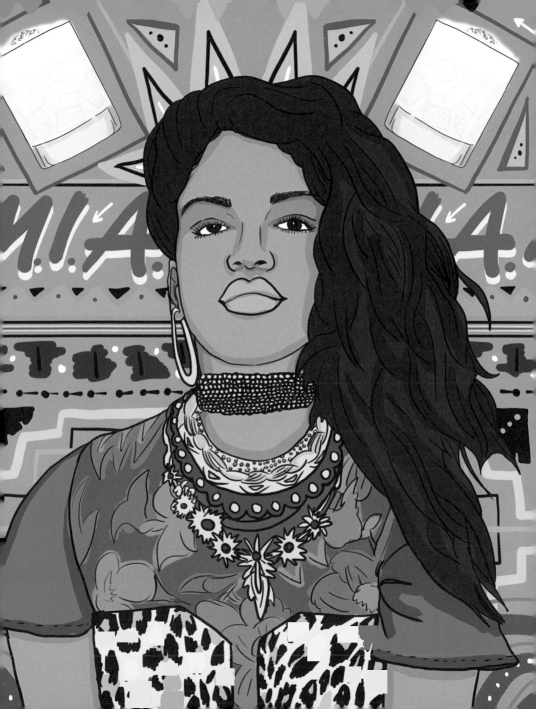

GRACE JONES

The Grace Jones

Gold sugar
 (such as Wilton Pearlized Sugar;
 you can buy this online)
1 lime
2 shots gold rum
1 shot crème de cacao
½ shot fresh lime juice

Pour a thin layer of gold sugar
onto a plate. Run a slice of lime
around the edge of a Martini glass
and dip into gold sugar to rim.
Pour all liquid ingredients into
a shaker filled with ice and strain
into the glass.

Haughty and gorgeous, the Jamaican-born model/singer/
actor Grace Jones defined androgynous style for generations,
changing beauty standards in the process. After moving
to New York with her family at age 13, she began rebelling
against her strict parents by living in hippie communes and
working as a go-go dancer. By the age of 18, she had already
signed her first modeling contract. This took Jones to
Paris, where her high cheekbones and angular features made
her a runway favorite for designers like Yves Saint Laurent
and Kenzo. She was also a talented singer and, after landing
a contract with Island Records, began recording disco and
New Wave music, leading to albums like *Nightclubbing*
and *Slave to the Rhythm*. Her daring performances at hip
New York nightspots like Studio 54 made her a darling of the
city's underground scene, and her creative partnership with
French graphic designer Jean-Paul Goude, who managed
her live shows and designed her album covers, turned Jones
into a pop culture icon. With her broad shoulders, flat-top
hairdo, mannish jackets, and futuristic accessories, she was
intensely glamorous, yet impossible to define. "I go feminine,
I go masculine—I am both, actually," she explained. Her
stardom led to roles in movies, including an infamous turn
as a Bond girl, where her sexy snarl terrified the actor
playing 007.

Jones often accessorizes with gold: gold jewelry, hats, masks,
and makeup, giving her an otherworldly glow. Her cocktail
is gold in liquid form, with hints of chocolate and citrus, and
a decadent golden rim.

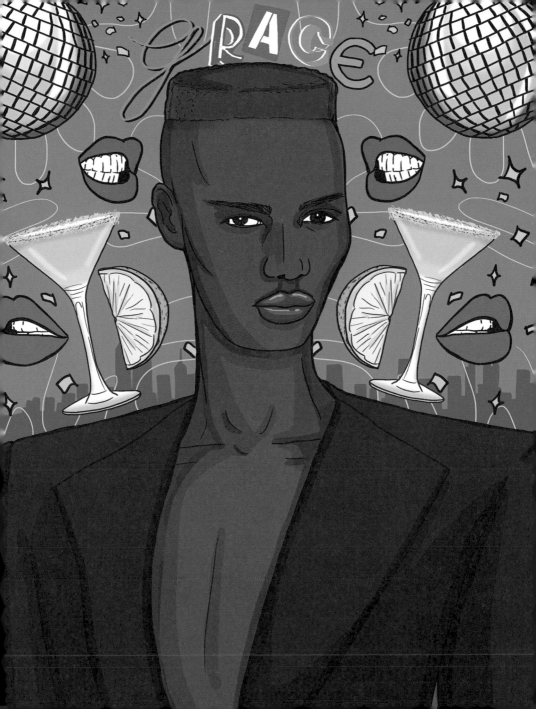

MELISSA MCCARTHY

The Melissa McCarthy

Tajín seasoning
 (or half-salt, half-chili
 powder mixture)
1 chili pepper
1½ shots silver tequila
½ shot maraschino liqueur
3 shots watermelon juice

Rim a rocks glass with Tajín and
fill with ice. Muddle a chili pepper
in the bottom of a shaker. Add all
liquid ingredients and shake with ice.
Strain into glass.

Melissa McCarthy brings the heat to every role she takes.
By advocating for herself and taking risks, the comic genius
and producer has become one of the most powerful (and
hilarious) actors working today.

McCarthy became a familiar face to TV audiences as
Sookie St. James on *Gilmore Girls*, but her breakthrough
came from playing the ridiculously inappropriate Megan
in the movie *Bridesmaids*. McCarthy improvised much of
Megan's action with wild abandon, and the shameless, bold
character became part of her own image. The role resulted
in an Oscar nomination, and helped her become one of the
highest-paid actors in Hollywood, paving the way for parts
in other films like *The Heat*, *Tammy*, and the all-female
reboot of *Ghostbusters*. Soon after that string of films,
McCarthy delivered one of her most notable performances
on *Saturday Night Live*—a wildly transgressive impression of
Trump's former White House Press Secretary Sean Spicer
(bug-eyed, screaming, and gesticulating) that won her
an Emmy.

Since then, McCarthy has continued to rack up memorable
roles, including as a charismatic, troubled novelist in the
trippy thriller *Nine Perfect Strangers* (on which she was also
a producer), and as the iconic sea witch Ursula in 2023's live
action version of *The Little Mermaid*.

Incorporating watermelon, tequila, and chili pepper,
McCarthy's cocktail is as fiery as her comedy.

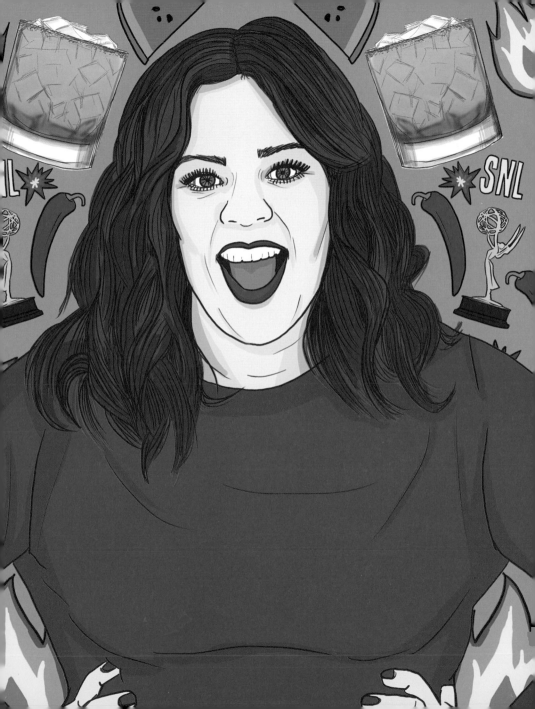

LAVERNE COX

Laverne Cox is a woman of many firsts. The first openly transgender woman to win a primetime Emmy, to star in a network drama, and to appear on the cover of *Time* magazine, just to name a few. She's widely been credited for breaking the glass ceiling for trans women in entertainment.

Her television career began as a contestant on the reality show *I Want to Work for Diddy*, which revolved around Sean "Puff Daddy" Combs' search for an assistant. It was a flash in the pan, but Cox's appearance marked the first time a Black trans person appeared on reality TV, and it gave her the visibility to land other roles. The biggest of those opportunities came with *Orange Is the New Black*, in which she played inmate Sophia Burset. Sophia was a nuanced, relatable trans character, and for her to actually be played by a trans actor was groundbreaking. Cox's warm, intelligent rendering of Sophia made her a fan favorite.

In the years since, Cox has become a stylish pop culture icon, making cameos on the cover of British *Vogue* and in Taylor Swift music videos (and earning a wax replica at Madame Tussauds). She has used her fame to advocate for trans rights; she knew it was important to become the role model she never had while growing up. Her words of encouragement are inspirational for anyone who feels like an outsider. She has said, "Believing you are unworthy of love and belonging—that who you are authentically is a sin or is wrong—is deadly. Who you are is beautiful and amazing."

Cox's cocktail is a blended Margarita with an unexpected ingredient: avocado. It's a fan favorite, too.

The Laverne Cox

2 shots silver tequila
1 shot Cointreau
1 shot fresh lime juice
½ avocado
1 tsp agave syrup
Garnish: lime wedge

Add all ingredients to a blender with ½ cup / 100 g ice and blend until smooth. Pour into a Hurricane glass and garnish with a lime wedge.

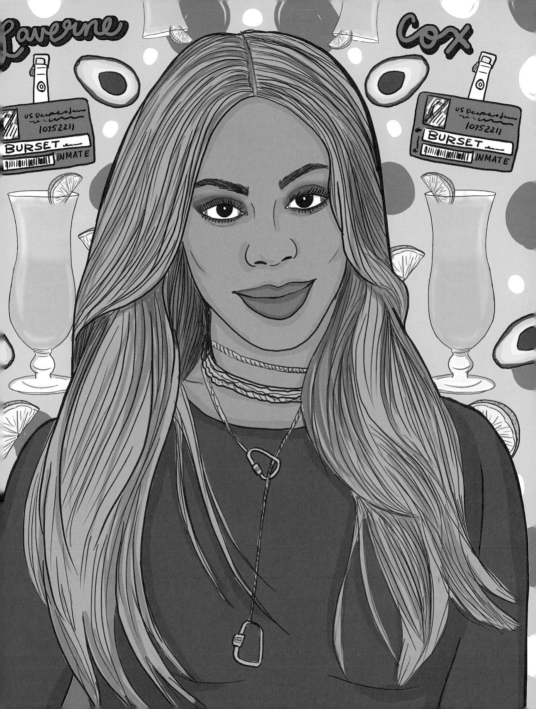

ANGELINA JOLIE

The Angelina Jolie

2 tsp sugar
1 stalk lemongrass,
 chopped into small pieces
1 lime (quartered)
6 to 8 fresh mint leaves
2 shots light rum
Club soda (soda water)
Garnish: mint sprig

Place sugar and lemongrass into a Collins glass. Muddle thoroughly with a muddler (lemongrass needs a bit of work!). Squeeze lime quarters into glass, add mint leaves, and muddle more. Add rum, stir, and add ice to glass. Top with club soda and garnish with a mint sprig.

Angelina Jolie embodies the ideals of movie stardom. Everything she does—from acting to adopting kids—looms larger than life. But she isn't content to just be a celebrity, and shines her megawatt fame on issues that matter.

As the daughter of actor Jon Voight, Jolie was born into Hollywood royalty but, in spite of that, she didn't find it easy to land roles when she first started out at age 16. She was a bit of a punk with a brooding attitude, and casting directors found her aesthetic "too dark." That changed after she was cast in *Gia*, a biopic about drug-addicted supermodel Gia Carangi, and *Girl, Interrupted*, in which Jolie ferociously embodied a patient living in a psychiatric hospital, a part that won her an Oscar. She went on to appear in both high-grossing action films like *Tomb Raider*, and critically-acclaimed dramas such as *Changeling*. She later took her talents behind the camera, directing films including *Unbroken* and *By the Sea*.

Jolie's moviemaking slowed down in 2002 owing to her commitment to something more pressing: humanitarian activism. While filming *Tomb Raider* she witnessed the humanitarian crisis in Cambodia, an experience that deeply affected her and compelled her to work with refugees. She began traveling to crisis zones on her own dime and spent over 20 years as an ambassador for the UN refugee agency UNHCR. In 2017, she brought her activism into her art with *First They Killed My Father*, a film she directed about the Khmer Rouge.

Jolie's cocktail is a Mojito with lemongrass, a flavor from the country that made her care more about the world.

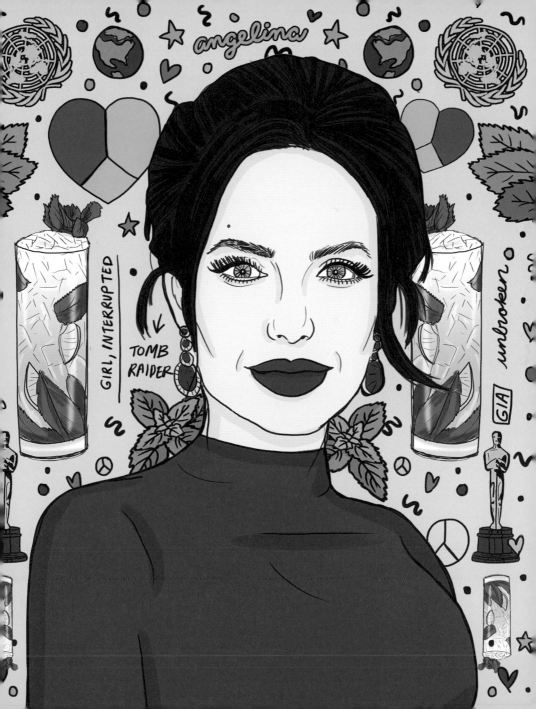

angelina

GIRL, INTERRUPTED

TOMB
RAIDER

GIA unbroken

b. 1988

RIHANNA

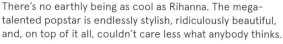

There's no earthly being as cool as Rihanna. The mega-talented popstar is endlessly stylish, ridiculously beautiful, and, on top of it all, couldn't care less what anybody thinks.

Born in Barbados, Rihanna was scouted by a record producer when she was still in high school and, by age 17, had scored a six-album deal. It didn't take long for her to become world-famous, and the songs she's recorded over the years, like "Umbrella," "Rude Boy," and "Work," are undeniable earworms full of attitude. And attitude is what Rihanna has in spades. It's visible in her style, which is provocative, daring, and sometimes avant-garde; she's sported everything from an outrageous Comme des Garçons tiered petal dress, to a completely see-through fishnet sheath with nothing but a thong underneath, to a series of sexy bump-revealing fits while pregnant with her first child with A$AP Rocky in 2022, and a va-va-voom red number for a second pregnancy reveal during her Super Bowl halftime performance in 2023. You can see it in her music videos, most notably the controversial "Bitch Better Have My Money," which depicted Rihanna's most hardcore revenge fantasy. It's also evident in the way she parties without fear—tabloid coverage be damned—and flaunts her love life and changing body without worrying about the repercussions. Today, she channels that confidence into her bold and inclusive lingerie line, Savage x Fenty, and her popular cosmetics line, Fenty.

The Rihanna

1½ shots gold rum
1½ shots coconut water
½ shot fresh lime juice
½ shot pineapple juice
½ shot agave syrup
Garnish: edible orchid

Add all ingredients to an ice-filled shaker and shake. Strain into a cocktail glass and garnish with an edible orchid.

Considering that she's from Barbados, a tropical island, it's not a big surprise that Rihanna loves coconut water (she was even once the face of the Vita Coco brand). Her cocktail is a more sophisticated riff on a Piña Colada.

136

IRIS APFEL

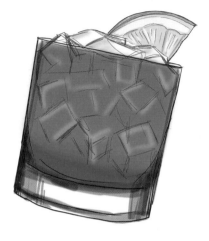

The Iris Apfel

**2 shots Campari
6 shots club soda (soda water)
Garnish: orange slice**

**Add ice to a rocks glass. Pour in
Campari and top with club soda.
Garnish with an orange slice.**

With her colorful, baroque style aesthetic and signature oversized black-framed glasses, Iris Apfel is an unconventional fashion muse who inspires designer collections and museum shows. A true late bloomer, the now-centenarian became an internationally recognized icon at the age of 83.

Though the world didn't discover her until somewhat recently, Apfel's outrageous style has always been in full effect. When she was young, she won a writing prize from *Vogue* magazine, which led to a job at *Women's Wear Daily*. In 1950, when she was 29, she and her husband launched Old World Weavers, a textile company that specialized in recreating antique fabrics. It was so successful that it counted several American presidents as clients, and Apfel's business travels took her around the world—giving her the opportunity to buy one-of-a-kind clothes and accessories from different countries.

She became a celebrity in 2005 when the Metropolitan Museum of Art in New York staged an exhibition of her eccentric wardrobe, which ran the gamut from high-end designer pieces to handcrafted antique jewelry and flea market finds. Today, Apfel is an influential tastemaker who sits front row at fashion week, appears on magazine covers, and even has her own makeup line. In 2019, at age 97, she made headlines when she signed with modeling agency IMG. She's almost singlehandedly changed the way people think about old age and style: now, fashion isn't only for the young.

Apfel's favorite drink is Campari and soda; she's so particular about how it's made that, rather than leave it to the bartender, she demands a glass, a bottle of Campari, and some club soda on the side, so she can make it herself. "I do my concoction like a chemist," she has said.

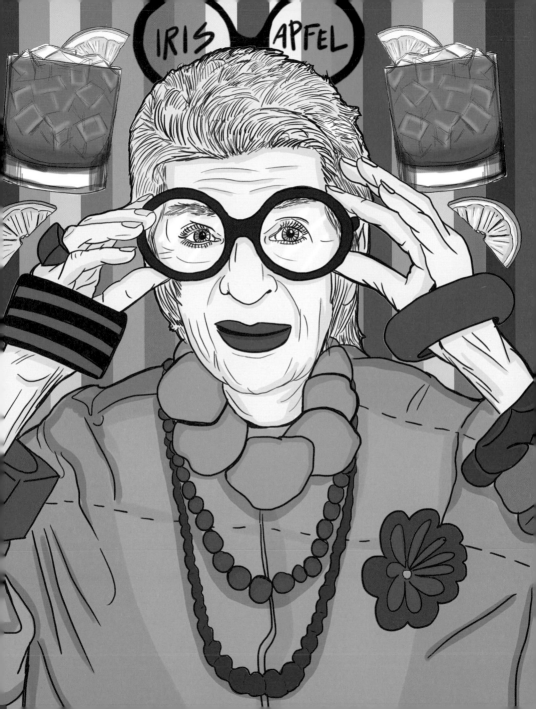

Biographies

Jennifer Croll is a writer and editor who lives in Vancouver, Canada, with her stylish and handsome tuxedo cat, Ollie. Her other cocktail books include *Buzzworthy*, *Dressed to Swill*, and *Art Boozel*. During daylight hours, she's an editor at Greystone Books, and by night, she drinks cocktails.

Jen fondly recalls the first tribute cocktail she ever drank; of course, it was a Shirley Temple when she was 12 years old. But if you're buying, she'd prefer a mezcal Margarita, on the rocks.

Kelly Shami is an artist who was born in New Jersey and now lives and works in New York City. Her practice focuses on oil painting, and she has shown in galleries in New York and Los Angeles. This is her first illustrated book, which in her opinion calls for a drink. She prefers champagne with a splash of Chambord.

Acknowledgments

Jennifer Croll

I'm very grateful to everyone who helped free the tipple. In particular, editor Ali Gitlow, who smartly guided this book from beginning to end and is largely responsible for its existence. Kelly Shami, your illustrations are what made this book come alive, and I cannot stop staring at them. They (and you) are amazing. Martha Jay, thank you for your careful eye; without your copyediting and proofreading, who knows what chaos would have befallen our readers' home bars. Nina Jua Klein, your design made it all come together. And I can't forget Prestel's sales and marketing team, who are responsible for getting this tiny tome into the hands of readers. On the home front, I'm indebted to Kevin Brownlee, who offered me some early, sage advice on cocktail best practices. Thank you to Michael Mann, who delivered me a half-finished bottle of crème de cacao at midnight on a Monday. And cheers to all my friends who helped me test cocktails at one point or another, and to everyone at Greystone who aided and abetted my moonlight career. You're all awesome, and we should go for drinks.

Kelly Shami

To our captain, Ali Gitlow: without your guidance this book would not have been possible. Thank you for being the absolute best. Jen Croll, you have impeccable taste. The drinks are so uniquely refreshing and your words always taught me something new. To Nina Jua Klein, a magical fairy who made putting this book together look so easy. Thank you Prestel for allowing me to illustrate my first book! Thank you to my parents, Carla and Tony Shami, for always supporting my unconventional artist lifestyle. Your sacrifices and support are everything to me. To Christian Condina, who spent many nights watching me stress over deadlines while binge-watching all kinds of television to keep the momentum going, you are my rock. Thank you to all the women who are positive forces in my life: Maryrose Koumi, Danielle Guizio, Nicole Ponti, Shamron Koumi, Kim Romano, Ashley Condina, and my youngest light, Izla Koumi. To my brother: although this book is about all the strong females through history, you are a prime example of a man in this modern world who lifts up the women around him. Every male should rip a page from Mark Shami's book. Lastly, thank you to all the women in history who continue to set examples for generations to come.

© Prestel Verlag, Munich · London · New York, 2023
A member of Penguin Random House Verlagsgruppe GmbH
Neumarkter Strasse 28 · 81673 Munich

© for the text by Jennifer Croll, 2023
© for the illustrations by Kelly Shami, 2018

Library of Congress Control Number: 2023935095

A CIP catalogue record for this book is available from the
British Library.

Editorial direction: Ali Gitlow
Copyediting and proofreading: Martha Jay
Design and layout: Nina Jua Klein
Production management: Luisa Klose
Separations: Reproline Mediateam
Printing and binding: DZS Grafik d.o.o., Ljubljana
Paper: Profibulk

MIX
Paper | Supporting
responsible forestry
FSC® C106600
FSC
www.fsc.org

Penguin Random House Verlagsgruppe FSC® N001967

Printed in Slovenia

ISBN 978-3-7913-8988-2

www.prestel.com